COLLECT

contemporary | **photography**

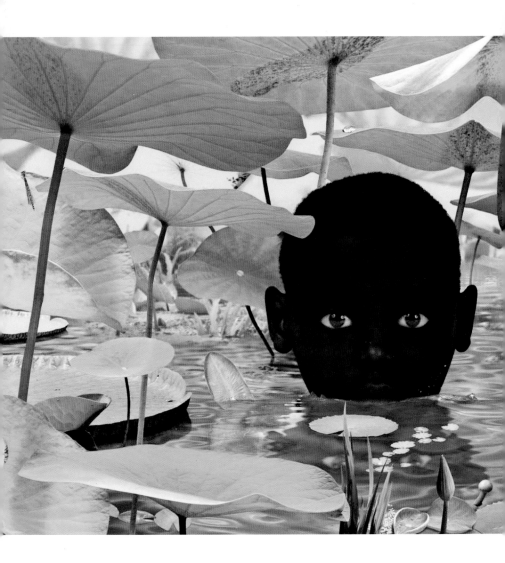

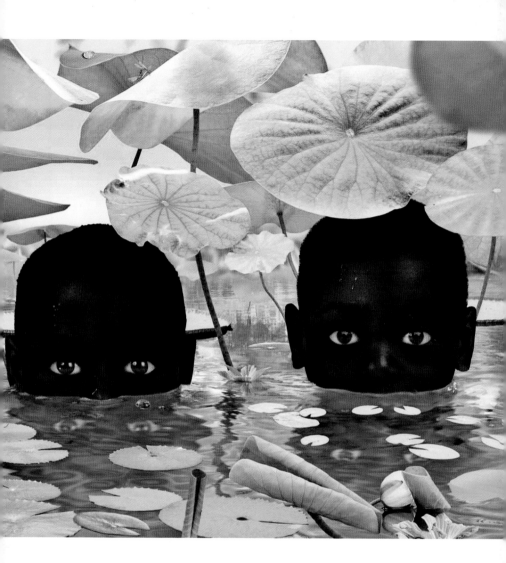

COLLECT
contemporary | **photography**

jocelyn phillips

edited by malcolm cossons

with 153 illustrations, 139 in colour

 Thames & Hudson

PREVIOUS PAGES
ruud van empel
world #25, 2007

First published in the United Kingdom in 2012 by
Thames & Hudson Ltd,
181A High Holborn,
London WC1V 7QX

British Library Cataloguing-in-Publication Data
A catalogue record for this book is available from the
British Library

ISBN 978-0-500-28854-2

Printed and bound in China by C&C Offset Printing Co. Ltd

To find out about all our publications, please visit
www.thamesandhudson.com. There you can subscribe to
our e-newsletter, browse or download our current catalogue,
and buy any titles that are in print.

contents

introduction

In the context of art history, the medium of photography is still in its infancy. A little over a hundred and fifty years old, it is a relative newcomer compared to sculpture, painting or drawing – yet it has had an immense cultural impact in such a short time.

Right from its beginnings in the 19th century, photography provoked great debate. Critics and supporters alike questioned its artistic merit: for many it was seen only as a means to document 'reality'. However, photography pioneers William Henry Fox Talbot and Louis-Jacques-Mandé Daguerre also saw the aesthetic potential of their creations beyond their ability to record their surroundings accurately. In fact, Talbot named his process the 'calotype' after the Greek *kalos*, meaning beautiful.

For much of its early history, photography was defined in relation to other art forms, notably painting, but it did not remain in this sub ordinate position for long. Following rapid technological developments, from the 1840s onwards many studios and photography businesses were established all over the world. With the advent of the first Kodak camera in 1888, the medium became accessible to the wider public and a more concrete distinction was made between amateur and professional. Since then, many have attempted to categorize the different forms of photography, yet the fluid nature of the medium has resisted classification – photography has followed a varied course and continues to provide a wealth of imagery from a multitude of back-grounds and disciplines.

Today, photography is central to our visual culture. Indeed, the same features it was criticized for at its inception – the way it can be reproduced and accessed – have secured this position of importance. Technological innovations in the 20th and 21st centuries provided the means for easy dissemination of images, and photography established itself as an essential form of communication in journalism, fashion, advertising, law, science and many other fields. The photograph has become the most common way of looking at and understanding the world, and we are now used to encountering countless images every day.

Firmly established as an artistic medium, photography features prominently in the collections of many major cultural institutions

denis darzacq
hyper no. 20, 2007

across the world, and there is an ongoing academic discourse on the subject. Many contemporary artists who were originally working in other media have been drawn to photography, relishing its adaptability and discovering in it new, unconventional means of expression. In adopting photography, these artists have helped to make it the driving visual force of our time, and they continue to challenge our understanding of the field with their work.

With the growing importance of the photographic image the photographic print has also gained value as an object of desire for collectors. This book examines the photograph as both image and physical object and concentrates on the key aspects of buying contemporary photography, exploring methods of production, materials and presentation so that collectors have a good understanding of what to look for when making a purchase. There is also a practical section with advice on print handling and conservation, and a list of relevant contacts. Contemporary photographers have their pick of a wide range of materials and may print the same image using different processes over time. For this reason, the photographs in the book are captioned by image title and date only.

Forty of the most influential practitioners of contemporary photography are presented in individual profiles in the book. Given the number of photographs being produced at any one time, this selection can be only a snapshot, representing those who have made significant contributions to the medium over the past four decades – both established photographers and new names to watch. Coming from all over the world, these photographers demonstrate the depth and range of artistic output today. Their work references the history of photography to which it is indebted, while continually developing the medium and establishing new trends. The profiles do not attempt to define the practitioners or their work and cover both those who work solely with photography and those who work across many media of which photography is only one: the nature of the medium has, after all, been democratic from the outset.

naoya hatakeyama
slow glass/tokyo, 2008

buying contemporary photography

Building a photography collection is a journey of discovering tastes and interests. It is a process in which the photograph as image and the photographic print as physical object are of equal importance. The idea of the photograph as a collectable item is still relatively new: for much of the early history of the medium the notion of a photograph having commercial value to collectors was more or less unheard of.

Today, there are more artists working with photography than ever before, and a wealth of galleries and institutions display photographs. It is a relatively young market, and photography is still deemed accessible in terms of price and therefore ripe for exploration. Young and emerging photographers in particular often sell works from £200/$300

wang quingsong
follow me, 2003

or even less, and it is the discovery of these, alongside the appreciation of past masters and established practitioners, that makes collecting photography such a varied and rewarding experience.

Graduate shows, photography fairs, museum collections, auction houses, private dealers and commercial galleries are all ideal places to discover what aspects of photography appeal. It is also important to familiarize oneself with aspects such as different print sizes, colour and monochrome, framing, mounting and printing techniques, photographic style and art historical influences. Whether buying for the love of the medium, for investment, or a little of both, this is an exciting time for collectors.

izima kaoru
reika hashimoto
wears milk (444), 2006

photography as art

The history of photography encompasses a multitude of different genres. In the first decade after the invention of the medium, the portrait was the most popular form; portrait studios were rapidly set up across Europe and North America, while from the 1850s onwards photographers began to travel the world, documenting new landscapes and peoples and recording the battlefields of the Crimea, India and America. Photography was also used to aid scientific discovery, deployed in physiognomic studies and experiments to study sequences of movement in humans and animals. By the 1880s the photographic image could easily be printed together with type, thus increasing demand for photographs. Into the 20th century and beyond, genres have expanded further to include photojournalism, fashion, advertising and other commercial applications.

This briefest of glances at the history of the medium cannot do full justice to the subject nor capture all the ways in which photographic 'categories' are fluid. The accessibility and the enduring nature of the photographic image have been discovered by successive generations, and the great appeal of the medium lies in its resistance to formal classification. A photograph can encompass universal themes and multiple interpretations: a military photograph, for example, can be both a topographical record and a piece of photojournalism; it can be read as a descriptive image or as propaganda; it may have been shot on assignment, on commission or as part of an individual project. Certain images, initially conceived in a particular genre, have, over time, transcended their category and been re-examined in an artistic context. 'Art' may be just another label to attribute to particular photographs, but it is the label that, in the commercial market, invests the image with great financial value and a special appeal to collectors. But when does the 'craft' of a photojournalist become 'art'?

The photograph has become an integral part of our visual and cultural subconscious, and this familiarity with images also produces a desire to own copies of them. It is the photograph as object that has the potential for commercial value as a work of art. To some extent, photography has been hampered by its own nature – the way

it can be easily accessed and reproduced – as this has led some to question the rarity of individual prints and to suggest that anyone can take a photograph and sell it. While there is now no doubt about the photograph's place in a fine art gallery, it is interesting to observe that many of today's practitioners still prefer to label themselves as 'artists' rather than 'photographers', indicating a desire to shrug off any lingering suspicion that their photography could be categorized as something other than 'art'.

However, focusing on categories is beside the point. The market for photographs has continually shown that unusual and innovative images, particularly the most beautifully crafted prints that are rare or deliberately limited in edition, elicit most interest and ultimately command the highest prices. For early practitioners, who were creating images when a market for photographs simply did not yet exist, these aspects were to some extent left to chance. Contemporary photographers, in contrast, have a greater awareness and an ability to control their output so as to encourage its appreciation as art. Inspired by the development of comparable markets such as those of painting, prints and sculpture, today's photographers can shape the direction and reception of their work through format and chosen materials, outlets for sale and exhibition and, of course, through their own technical ability and artistic imagination.

the artists' materials

The early years of photographic history contain fascinating stories of scientific discovery. The speed with which early practitioners developed and honed different processes and techniques, as they searched for the fastest means of capturing images and the most stable way of developing them, is impressive. Today, photographers have many choices when selecting suitable materials for their work. These choices have a bearing on the aesthetic as well as the practical and commercial aspects of the work. There is a multitude of different photographic processes, some stretching back to the 19th century, others of much more recent innovation. Some technical processes are very complex and not to be described in detail here, but it is important for

photography collectors to have a basic understanding of some of the terms commonly used in the field:

gelatin silver print: The most common form of black-and-white photography in the 20th century, this is a process by which a latent image is created through the action of light on paper coated with silver salts, held in a gelatin emulsion and developed in the darkroom. It first came into use in the 1880s, replacing the common albumen silver print as a more stable process and one that allowed for developments such as image enlargement.

platinum print: A black-and-white process also in use from the 1880s onwards and popular until rising platinum prices in the 1920s and 1930s made production costs prohibitive. Palladium was often sought as a substitute at the time, and both palladium and platinum-palladium prints are still existent. The process is similar to the silver print, but with the final image produced from platinum salts (as opposed to silver salts), which are absorbed by the paper itself. In more recent years this process has enjoyed a revival for reprints of images by early 20th-century photographers, as well as by some contemporary practitioners. The process is favoured for its greater stability over a silver print and its broad tonal range.

chromogenic print: Developed in the 1950s, chromogenic prints are often called C-type prints, or just C-prints, and they are the most popular form of modern colour photography. They are created using colour-sensitive emulsion layers in the paper, each of which responds to the respective primary colours of light (red, green and blue). After the initial development stage, chemical compounds called dye-couplers are added to form layers of colour that are superimposed on each other, forming the full-colour image.

dye-transfer print: In use from the 1870s, this is an extremely stable colour process where the print is created using a gelatin mould. Three negatives (one for each primary colour) are made from photographing

the original colour transparency, then three moulds are made from these negatives, using a gelatin-coated film. Each mould is then placed in the appropriately coloured dye bath (cyan, magenta or yellow) before being applied to paper to produce the final image.

digital print: The photographic image is digitized, either by scanning the original negative or transparency or, more commonly, through direct transfer of the file from a digital camera to a computer. The photographic file is then prepared for printing, with any colour or other manipulation achieved by using specialist software. The printing process – monochrome or full-colour – is essentially controlled by the computer.

There have been several different kinds of digital print in use since the 1990s, the most common being the inkjet print. In this process, the printer sprays minute droplets of ink on to the paper in the manner of an airbrush, layering them to form the complete image. The Iris print is similar to the inkjet and takes its name from the printer on which it is produced. The term Giclée print is also used to describe similar prints, and the three terms have now started to become interchangeable. With each of these processes, a variety of papers can be used, needing only to fit the specifications of the printer. Another form of digital print is created with the Lambda process, which involves the digital image being printed using computer technology on traditional silver materials.

Digital photography is the most recent significant innovation in the field: it has changed the way many practitioners work, and commentators suggest it will herald the end of the darkroom and traditional processes within decades. Alongside this, developments in digital manipulation including Photoshop and other computer software, give photographers ever greater control, enabling them to manipulate their work as never before. The work traditionally done to negatives in the darkroom to create a desired effect can now be achieved with the click of a mouse.

As production processes have changed, so too have the ways in which photographers mount and present their work. No longer simply

alex prager
maggie 24, 2010

applying photographic paper to a thicker paper stock, artists now use a range of archival-standard cards and boards, and stronger supports such as aluminium and Plexiglas are also increasingly popular. This has implications for the collector: while it is important to ensure that a piece is well protected from creasing, large mounts can be heavy and difficult to manage. It is therefore wise to consider any photograph you are thinking of buying not simply as an image, but to bear in mind its actual dimensions and physical presence in relation to the space you have for storing or displaying it. Increasingly, artists view the mounting and framing of their images as integral to the overall piece, so discuss this with the gallery or photographer. An original mounting to the artist's own specifications will in time lend value to the piece as it will add to

the authenticity of the work. It is also important to be aware of the implications of any storage and conservation needs.

editions and authenticity

The process by which photographers authenticate their work has become increasingly important as the market for photographs as fine-art collectibles has developed. As photography specialists are fond of saying, the back of a print can tell you more about a photograph than the front. This is because, traditionally, it is there that one finds the photographer's signature, annotations or ink stamp. The stamp might

idris khan
blossfeldt... after karl
blossfeldt 'artforms
in nature', 2005

contain copyright or reproduction rights information, negative and series details or the photographer's studio address. The latter can be useful with older photographs when trying to determine a print's date. Problems of attribution, dating and authentication relating to early photographic material have underlined the importance for contemporary photographers to label each print clearly. Today, you might find the photographer's signature on the front or back of a print. Ink stamps are still widely used, as are embossed stamps (blindstamps), while many contemporary photographers choose to affix signed labels to their works (usually to the reverse of the mounting) that give the full print details: title, date, process, dimensions and edition size.

Such detailed labelling has allowed for far greater clarity for both the individual collector and the wider art market and ensures that in years to come the exact status of an individual print will be easier to determine. It is also now quite common for photographers to produce certificates of authenticity to accompany their prints, confirming the details of a specific print. Sometimes these certificates are signed and act in place of a signature or signed label on the print. In such cases it is vital to keep the certificate safe, as it is an integral part of the artwork, serving as proof of the work's authenticity and, in future, ensuring its value as a piece executed by that particular artist. If you are purchasing a photograph that has already been signed and authenticated by the photographer but are keen to have a certificate alongside this, you can request one and, although it may not be the photographer's standard practice, many will be happy to oblige. You should also retain any invoice documents provided by the photographer or gallery. As proof of purchase and for immediate insurance advice, they can be invaluable.

The process of making prints in limited editions has further encouraged the idea that a photographer's output can be tracked for posterity. As photographers have sought over the years to market their works as fine art, they have drawn on lessons learned from the art market. They have understood the importance of giving collectors the assurance that what they are acquiring is limited in number and, as a result, highly sought-after. It is therefore common to find contemporary photographers producing prints of their images in several limited

editions. An artist may choose to print three examples of an image in a large format of 100 × 100 cm (39 × 39 in.); to accommodate those collectors seeking a smaller print they might produce another edition of ten prints at a slightly smaller size of 75 × 75 cm (30 × 30 in.); finally, a third edition of, say, twenty-five copies will be made in an even more accessible size of 45 × 45 cm (18 × 18 in.). In this way, not only has the photographer carefully catered for collectors of different means, but they have also ensured that, in whatever format a collector is buying, the acquired print will be one of only a few similar items in the world. It is common practice for photographers to create a few (generally no more than five) Artist's Proofs (APs), which are additional prints made with the set edition size. While the artist or gallery often retains these initially, the prints can in time be released for sale and find their way onto the market. While APs are limited to small numbers, this does not usually affect the desirability of the overall edition, as an artist or gallery with good practice will make it clear on any purchase paperwork or on the print itself that the edition consists of a certain number, plus Artist Proofs.

In terms of price, it follows that prints in smaller limited editions are more expensive than those produced in more widely available editions. It is also worth noting that many photographers, as well as the galleries that represent them, will charge increasing amounts for the same image as an edition runs out. So, for example, a gallery may charge £500/$800 for number one in an edition of ten, but significantly more for number ten. Any relevant taxes will be applicable on retail prices, although this is usually made clear when the price is quoted. Likewise it will be apparent whether your price includes framing or not. Many contemporary photographers present their work for sale already mounted and framed to their own specifications, but some galleries will offer this service after purchase, allowing buyers to decide how they want the work displayed. In these matters, do not be afraid to ask. You may find that a photographer is particular about mounting or framing, viewing it as an integral part of the piece, but not everyone will want to influence the buyer. Do not hesitate to seek clarification on the price structure either. People approach collecting in different ways and it is

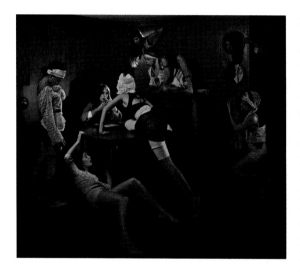

nazif topçuoğlu
hunger, 2011

not unusual, for example, for a collector to purchase the same edition number for each work for their collection, irrespective of the artist, format, style or process. If the number five is your 'lucky number', do not hold back from asking the gallery to supply you with this directly, whether numbers one to four have already been sold or not. This may also put you in a position to negotiate on the price, seeking a discount if there is a listed price for that particular number in the edition because those before it remain unsold. Remember, if you are buying more than one work by the same artist or from the same exhibition, you may have an extra opportunity to negotiate.

The final area to consider is the issue of 'vintage'. This may not seem immediately pertinent to a discussion about contemporary art, but the word has a particular meaning in the world of photography. It refers to the date of the print in relation to the date of the image (i.e., the negative). Generally, a print is deemed to be 'vintage' if it was made within five years of the date of the negative. After this, it will be described as a 'later print' or 'modern print'. The more accurate photographers are about recording print dates during their career, the more precisely later generations can catalogue and understand their work and methods. Today's photographers may decide to reprint some of their early work in decades to come in new editions. This has happened with prints from the early 20th century, meaning that, for reasons of rarity and originality, there has tended to be a market bias towards vintage material. As a general rule, work closest in date to the negative, produced by the artist to their own specifications and with their marks of authentication, will hold greater value than later prints of the same image.

photobooks

A growing area of interest for many collectors of photography is that of the artist book or photobook. From the early beginnings it was a way for enthusiasts to own the work of a certain photographer without necessarily going to the expense of purchasing individual exhibition prints, and it has developed into an important collecting area in its own right – one that stands alone but which can also superbly complement a collection of original prints. First editions and rare or out-of-print publications can now command high prices with specialist booksellers or at auction. Reference material written on the subject in the last decade (*The Photobook Vols I and II* by M. Parr and G. Badger, for example) has put photobooks on the map for collectors, placing them within the wider history of photography and printed matter. The photobook provides an excellent medium for appreciating the scope of an artist's work, while aiding the selection process when it comes to purchasing original prints.

sourcing photographs

The reference section in this book provides a list of galleries and contacts (pages 199–206) that will be useful when starting a collection. It is important to see as much work as possible before committing to a purchase. This can be done by visiting photography exhibitions at public institutions, and going to fairs, commercial galleries and auction houses. You will start to gain a sense of the kind of work that appeals to you: which photographers working in which genres and formats; particular processes and the aesthetic effect of the different kinds of print. Most importantly, you will have the chance to view works up close, to inspect their surface and condition, so that you are not simply purchasing an image from a catalogue. You may find that there are recurring themes that link a variety of seemingly different work for you, or you may favour a select group of artists. It is always worth considering a purchase not in isolation but in reference to those you have made before, to assess how it might enhance or change your growing collection. The gallery a contemporary photographer has chosen for representation will often give you a sense of the kind of work they

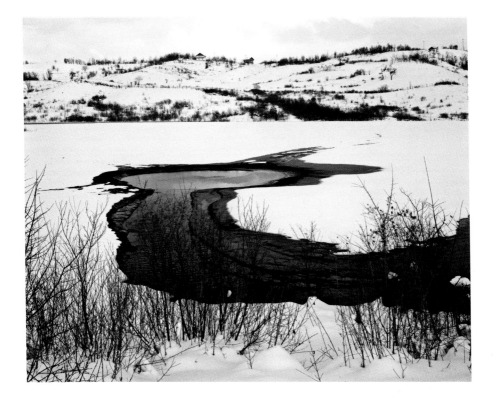

**simon norfolk
red lake, 2005:**
aluminium waste pond
at petkovici, where
hundreds of bosnian
boys and men were
executed in 1995

produce; consult any material they have produced about their shows or go to see the work of other artists also represented by them. The photographer's own statements about their work and any discussions you initiate will further inform your choices. Remember, it is you who decides on a certain piece and you should find renewed beauty in it each day.

As a contemporary collector you would be well advised not to expect a fast return on a photograph if buying for investment. It is a relatively young market and the overall trend for prices of photographic prints is still upwards; but like all other markets it is susceptible to the influences of wider cultural and economic events. That said, collectors who were astute enough to buy prints in the 1970s and 1980s might now see impressive returns. What is most important, however, is the enjoyment of collecting, and the educational process that goes with it in the development of a collection that compliments not just your taste but also the place where you have chosen to display it. A collection with recurring themes, and more than one work by a certain favoured photographer or group, will have a cohesion that is not just pleasing to the eye but that enhances the value of the collection as a whole unit, making it more than simply the sum of its individual parts.

miles aldridge

born: 1964, london, uk

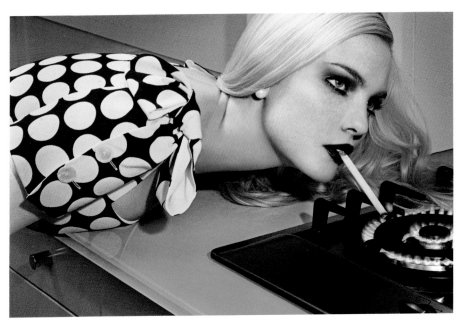

Miles Aldridge made his first foray into fashion photography in the mid-1990s at a time when the field was changing and a new aesthetic – later to be identified as 'grunge' – was developing, defined by supermodels such as Kate Moss. Previously, the genre had been dominated by black-and-white imagery and established names such as Peter Lindbergh, Mario Testino and David Sims. Aldridge entered this scene almost by chance. He had studied illustration at Central Saint Martins College of Art and Design in London and worked on videos for independent British bands such as Jesus and Mary Chain, but picked up a camera in order to help his girlfriend at the time build up a modelling portfolio. When her book was shown to casting directors at British *Vogue*, they showed an interest in the photographer, rather than the model. As Aldridge puts it: 'I became a photographer, she did not become a model.'

Those initial casting shots were natural and simplistic in style, and Aldridge soon realized that he wanted to do something different and began to develop the distinctive, colour-saturated, glossy style for which he is now known. He experimented partly out of a desire to break from the prevailing traditions in fashion photography, to avoid paying homage to the

giants of the field through cliché, and partly because of a strong feeling that 'photography could be more like painting', and that with the use of colour in particular 'you could be incredibly aggressive and dangerous'. Aldridge describes his style with the words 'colourful, plastic, strangeness'. It is this surreal aspect, and the complexity of the imagery, that marks him out from the fashion photography crowd.

Asked which photographers he admires, Aldridge answers: 'Only dead ones from the golden age: Avedon, Penn, Newton.' He mentions Richard Avedon for bringing story-telling to his fashion imagery and creating

fictional women; Irving Penn for enforcing rigour and seriousness and for his skill in close-up; and Helmut Newton for his bold and sexy, sometimes violent imagery, which has a clear influence on Aldridge's work. Motivated also by a love of cinema and drama, Aldridge cites films with strong female roles as a particular source of inspiration, for example the complex female characters created by Federico Fellini. Aldridge's models are often depicted with glazed eyes and far-away expressions. He asserts that this is not because there is nothing behind the look – rather, it represents the 'look of contemplation I see on people's faces when

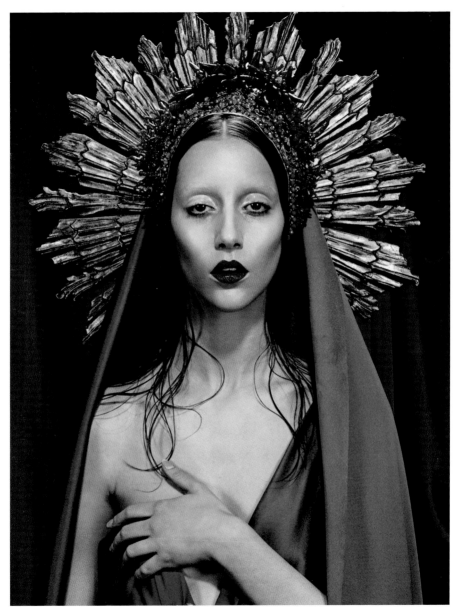

immaculée #3, 2007

they ride the bus or wait at the airport'. It is a look of common human experience. 'I want the women in my pictures to have a complicated internal life, but expressed through a rather doll-like exterior,' he says.

Aldridge is also influenced by his father, legendary graphic designer Alan Aldridge, who is celebrated for the iconic album covers he created for The Beatles and The Who, among others. In fact, Miles chose to train as an illustrator to follow in his father's footsteps, and an important aspect of his work today stems from this training: prior to each shoot, he sketches a storyboard, envisaging a series of images and finished results before even entering the studio. He approaches photography almost like a film director or a cameraman. His vivid imagination and obsession with detail ensure nothing is left to chance, but he also says: 'I enjoy seeing it changing before my eyes on the shoot. I am open to this change.' In 2009, Aldridge published *Pictures for Photographs*, a monograph with the drawings and sketches he made for various shoots, complete with directional notes and suggestions for colour and material; in the second half of the book the finished results are presented as photographs.

While each photographic image can be joined up with its preparatory sketch, the drawings have a clear presence and significance of their own.

A frequent contributor to Italian *Vogue*, *Numéro*, *Paradis* and *New York Times Magazine*, Aldridge is now finding his way from the magazine pages to art galleries. He talks of this shift – 'I used to imagine my pictures in magazines, now I see them in galleries' – as a significant change in his own perception of his career to date. He has exhibited at the Steven Kasher Gallery in New York and Hamiltons Gallery in London, and his photographs were included in the New York International Center for Photography 2009 group show 'Weird Beauty: Fashion Photography Now'. Aldridge was also invited to dress the windows of New York's Fifth Avenue boutique Henri Bendel, where he recreated some of his photographs with mannequins. Prints of his images can be found in the permanent collections of the National Portrait Gallery and the Victoria and Albert Museum in London, and in the International Center for Photography in New York.

benoit aquin

born: 1963, montreal, canada

Montreal-based photographer Benoit Aquin discovered photography as a four-year-old living with his family in Haiti, when his father gave him his first camera. He recalls taking photographs of his sister with their Tintin books, but never envisaged a career as a photographer until inspiration came in the form of the *Time Life* book series, which he was given in the 1970s. The pictures in the books clearly had a great effect on the young Aquin: 'Forty years later, certain images are still burnt in my mind,' he says. It was not until later, however, that

Aquin made the decision to study photography: 'I was assisting a professional photographer and messed up the project so much that I realized I had a lot to learn.'

Studying at the New England School of Photography in Boston in the mid-1980s, Aquin initially aimed to become a commercial photographer. Then he discovered *Telex Iran: In the Name of Revolution* by Gilles Peress – a publication credited with influencing many current photojournalists – and it completely changed his perspective. 'It made me want

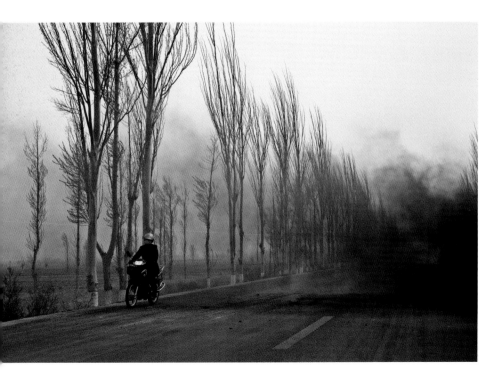

OPPOSITE
**la motocyclette, mongolie intérieure/
the motorcycle, inner mongolia
(the chinese dustbowl), 2006**

BELOW
l'envolée/the surge, 2010

to become an engaged photographer,' he says. For the next twelve years, from 1989, he worked as a staff photographer for alternative news weeklies such as *Voir* and *Hour*, documenting Montreal's urban scene. Since 2002, Aquin has been developing a career as an independent photographer while still working with key national and international publications including *Time, Canadian Geographic, Foto8,* Québecois magazine *L'actualité* and the *Guardian.*

Aquin's independent work focuses on humanitarian and ecological issues. He describes his style as 'strongly inspired by reality', adding: 'I like it when reality becomes magical; when reality becomes surreal.' While his views on photography have evolved throughout his career, and 'composition, colour, technique and concept may change', his aesthetic has remained constant. The projects he chooses are ones he feels passionate about, documenting for example what he describes as China's 'Dust Bowl' – the phenomenon of expanding deserts across the country (now covering eighteen per cent of the land), caused by the exploitation of arable land

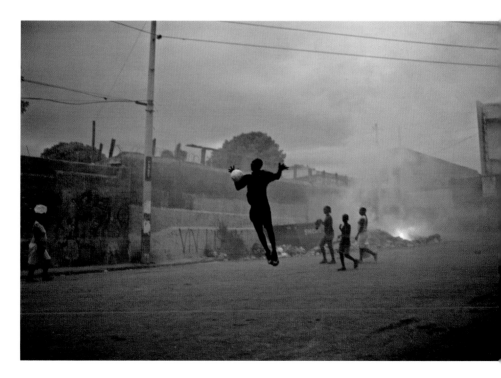

OPPOSITE TOP
**l'origine du monde/
the origin of the world
(chasse/hunting), 2002**

OPPOSITE BOTTOM
**maître d'impossible/
master of the impossible, 2010**

and deep drilling for water. With a neutral palette and sparse composition he shows the communities displaced by the advancing sand and highlights the Chinese government's efforts to halt this process through an environmental restoration initiative. In another stark examination of man's impact on the land and future generations, Aquin has recorded the effects of the use of the pesticide Nemagon on banana crops in Central America by companies such as Dole and Del Monte in the 1970s and 1980s. The plantation workers now suffer from incurable diseases and, where able to conceive at all, frequently bear children with deformities.

A recipient of several important awards, including, in 1996, the Grand Prix, the Prix du Jury and the Prix Le Soleil in the Regards du Québec competition and, more recently, the Prix Pictet in 2008, Aquin was given a grant by the Canada Council for the Arts in 2006 to develop his series *Travailleuses du sexe*, which documents Montreal's sex workers. Taking to the streets with a Polaroid camera, Aquin sought to capture the women on their own terms in an attempt to 'break the barrier between normal and marginal walks of life', and asked each sitter to write a few words about her state of mind. 'Establishing a conversation is such a simple yet privileged act,' he says.

Aquin's preferred method of working is now in digital format. While he continues to shoot some projects with traditional film, he finds the digital revolution has had a positive impact on photography in general. 'Digital has made photographs more widely available, and the quality is excellent. It has democratized colour photography, and there has also been a shift in the size of printing – we are now able to print easily in larger formats, which changes the visual impact.' Through organizing exhibitions of his work at commercial galleries, Aquin is aware of the effect large-format presentation can have on the audience but he confesses that he rarely thinks about his photographs as collectors' items: 'When I am shooting I am just concerned with taking good photographs.' Dedication to the project and a long-term goal are of paramount importance to him. He advises new practitioners to make the production of series a central part of their work: 'When you focus on a long-term project, you have an obligation to construct a series of images, which for me is one of the most challenging aspects of photography. It gives you the opportunity to grow because you have the time to reflect and build on your ideas.'

Having photographed Haiti in the aftermath of the January 2010 earthquake, Aquin is working on two new projects: the first being the continuation of his series *La Chasse*, begun in 2002, an examination of the activity of hunting as an ancient tradition with a long history of representation in art. The second is a long-term project documenting the world food crisis 'from the point of view of the peasant', aiming to show the lives of rural workers across the world and examine the issues of the economic crisis and the depletion of natural resources.

Aquin's photographs are held in the collections of the Canadian Museum of Contemporary Photography in Ottawa and the Musée national des beaux-arts du Québec, among others.

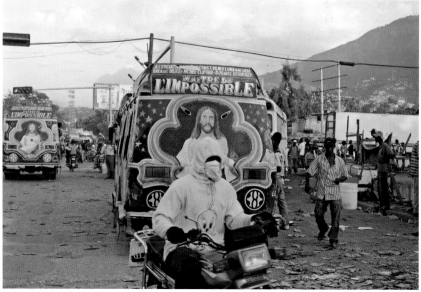

site specific_nyc 07, 2007

olivo barbieri

born: 1954, capri, italy

Olivo Barbieri is an architectural and landscape photographer with a difference. Shooting with a large-format view camera from a vantage point in a helicopter a few hundred feet above ground, he captures cities and towns as never seen before. At first glance, his delicate, immaculate and detailed creations appear fabricated. In fact, this 'perfect view' is a deliberate construct – reality shown without its imperfections. Barbieri's distinctive style is achieved through the use of a tilt-shift lens, which allows him to choose what to focus on and what to leave out of focus. The result is a condensation of space and blurring of reality, where buildings are idealized and references to military surveillance imagery are countered by a soft colour palette.

Site Specific (2003–present) is Barbieri's most significant project to date. For this series, he has photographed locations including Rome, Las Vegas, Shanghai, New York, Bangkok and Jordan, interpreting them all with his unique brand of architectural analysis. In the process, he invites viewers to re-examine their preconceptions about the urban landscape. This destruction of perspective and the 'normal' way in which things are viewed is key to Barbieri's artistic aim. He is not interested in a factual, documentary analysis of the metropolis, but seeks to create an atmospheric interpretation. He describes his style as 'straight philosophy' and talks fervently of the philosophical qualities of photography as a medium: 'Photography is immaterial,' he says, 'and yet it can be as strong as a philosophical statement.' He believes it is in fact 'the most important art form of our time'.

In *The Waterfall Project* (2006–7), Barbieri turned his lens on some of the world's most

LEFT
**dolomites project,
2010**

OPPOSITE
**iguazu,
argentina/brazil,
2007**

extraordinary natural features. Travelling to four continents, he captured the Niagara Falls in North America, the Victoria Falls in Africa, the Iguazu Falls in South America and the Khone Papheng in Asia. It is not only the landscape that we see but also, occasionally, some visitors come into focus as the photographer records the patterns of tourism. Again, he applies his characteristic visual effect to these works: the natural beauty of the places depicted is enhanced through the typical blurry areas that make other elements of the image, in sharper focus, pop with colour. He welcomes the technical innovations of recent years – 'nothing is like it was ten years ago…but in the best possible way' – and yet he is somewhat unusual among his peers in achieving his results without any digital manipulation. Looking at the finished results this is often hard to believe.

Following the theme of exploring nature, in 2010 Barbieri embarked on the *Dolomites Project*. As part of an initiative to promote the Dolomites as a UNESCO World Heritage Site, he travelled to the Italian Dolomite mountains, which he describes as 'planned architecture', and created a series of photographs together with a twelve-minute high-definition film. In this series, Barbieri reflects on issues of environment and sustainability.

Barbieri first started taking photographs as a child, encouraged and inspired by his uncle. He went on to study photography at the University of Bologna, where the theoretical side of the subject was emphasized, with the writings of eminent critics Roland Barthes, Susan Sontag and Jean Baudrillard as part of the course. Barbieri has said his destiny as a photographer was decided in part by reading a phrase by Man Ray: 'I paint what cannot be photographed…I photograph the things that I do not wish to paint.'

Having shown his work across Europe since the 1970s, Barbieri is now widely acclaimed at an international level, with solo exhibitions in New York, Shanghai, Auckland and Toronto. Printing his images with the help of assistants, in 'the best material available', Barbieri usually creates editions of six of each of his photographs. Prints of his images are held in major collections, including those of the Bibliothèque nationale de France in Paris, the Canadian Centre for Architecture in Montreal, the Centro Andaluz de Arte Contemporáneo in Seville and the San Francisco Museum of Modern Art.

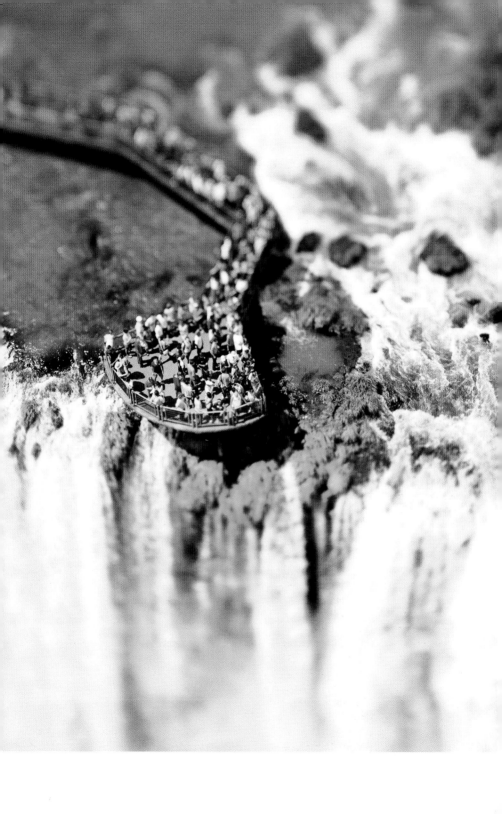

peter beard

born: 1938, new york, usa

Peter Beard's enduring love affair with Africa has been at the heart of his image-making for more than fifty years. Born in 1938, he started taking photographs aged twelve as a means of 'recording favourite things, of passing time and of stopping time'. These photographs became an extension of the diaries that he kept, which fuelled his interest in memory. Drawn from the outset to 'outstanding and life-enhancing female beauty' and to varied themes such as 'field day races, skiing, diving and stopped movement', he took a special interest in Africa, which was further developed on trips there in 1955 and 1960. In between he enrolled at Yale University as a pre-medical student, but soon switched to art history. In the early 1960s Beard worked at Tsavo National Park in Kenya and during his time there documented the demise of thousands of elephants and black rhinos. This experience inspired his book *The End of the Game*, published in 1965 and updated in 1977, which remains the work of which he is most proud.

Beard's friendship with *Out of Africa* author Karen Blixen had a significant influence on his early career. They first met shortly after Beard graduated from university in 1961. While at Tsavo, he acquired a property called Hog Ranch adjacent to Blixen's in Kenya's Ngong Hills, and Blixen is the subject of a number of his photographs. In addition to his photographic work he has collaborated on projects with artists including Francis Bacon, Andy Warhol and Truman Capote. Beard takes inspiration from the landscape that surrounds him and from an eclectic range of sources: he lists Hieronymus Bosch, Charles Darwin, Marcel Duchamp, Joe di Maggio, Albert Einstein and the Rolling Stones

among his heroes. Some of his favourite photographers are Julia Margaret Cameron, Matthew Brady, Miroslav Tichý, Brassaï, Jacques-Henri Lartigue and Les Krims. During his career Beard has moved with apparent ease between different social and artistic milieux – he is known on the fashion circuit, in Hollywood and in the New York art scene, where he is as much at home as in Africa. He has photographed celebrity friends including Mick Jagger, Iman and David Bowie.

To Beard the subject matter is the most important starting point for any would-be photographer, and this is evident in his own work: his images evoke the beauty and allure of the African landscape, its people and animals. Equally vividly, his lens captures the brutality of raw nature in depictions of animals in life and death. No stranger to the perils of his environment – Beard was mauled by an elephant in 1996 – he relishes the dangers of his adopted homeland. To enhance the photographic images, Beard embellishes them with drawings in ink and paint and often with smears of animal blood, feathers, skin, leaves or dirt taken from the land. These distinctive additions render each photograph different from the next: the same image may recur but the embellishments turn them into unique works of art. This particular aspect of his work has attracted collectors for many years. From small-format 20 × 30 cm (8 × 12 in.) prints featuring subtle ink-work to large-scale works adorned with feathers or snakeskin, Beard caters for both conservative and more daring collectors. He advises new collectors to 'go for the great, the rare, the non-clichéd, the historical…for

jenny and her jewelry, 2005–6

single cheetah, 1960/2007

time-capsule thinking, the authentic' – ideas that characterize his own work. It is the 'moments of authenticity and voyeurism', clearly present in his output, that draw people to his photography.

The first exhibition of Beard's work took place in New York at Blum Helman Gallery in 1975 and was followed two years later by his first solo show. Held at the International Center of Photography, it consisted of an installation of photographs, burnt diaries, books, elephant carcasses, taxidermy items and various African artefacts. Since then his work has been exhibited around the world – in London, Paris, Berlin, Milan, Tokyo and many other places – to great acclaim. Beard says of his work that he 'gets more into it' the longer he works with photography, and he continues to publish books of his images, recent examples being *Zara's Tales: Perilous Escapades in Equatorial Africa*, written for his daughter in 2004, and *Peter Beard* in 2006. In 2009, he produced his first Pirelli calendar. He divides his time between homes in New York and East Africa. A permanent retrospective of his work is on display at The Time Is Always Now Gallery in New York.

jonas bendiksen

born: 1977, tønsberg, norway

'I am a very simple photographer. There is no hocus pocus to anything I do. I am curious about people and use photography to engage with them,' says Norwegian photographer Jonas Bendiksen of the work that, even in his short career, has gained him recognition on an international scale. A full member of Magnum since 2008, Bendiksen has been working for the agency in some form since he was nineteen years old, when he joined the London office as an intern. His introduction to photography came some time before that, however, as a curious teenager at home: 'I started photographing when I was fourteen or fifteen years old, when I picked up my dad's old SLR,' he explains. 'I was immediately smitten with the magic of the process, built a darkroom in the family bathroom and spent my high-school years taking and developing pictures.'

After his initial internship with Magnum, Bendiksen left for Russia to pursue his own work as a photojournalist. Spending seven years there, he captured stories from the edges of the former Soviet Union, visiting different communities and enclaves to uncover their ways of life. Eastern Europe, Central Asia, the Caucasus and Siberia – all are examined in little-known places as Bendiksen's powerful images reveal people's search for stability and identity through history, religion and ideology. His images appeared in book format in the 2006 publication *Satellites*. It is this project, alongside the 2008 book *The Places We Live*, that Bendiksen cites as the most important of his work to date. 'They are quite different,' he admits, 'but have a common denominator.' *The Places We Live* gathers together images taken between 2005 and 2007

in Nairobi, Mumbai, Jakarta and Caracas. The book seeks to draw attention to the startling shift that has occurred in the way people live across the world, with an ever-increasing number inhabiting cities rather than rural areas. This urbanization trend has led to an explosion of city slums. It is this way of life, and the personal histories within the densely populated neighbourhoods, that Bendiksen captures successfully. He demonstrates an ability to create haunting images, finding the beautiful and ethereal in adverse, extreme situations.

The story or idea behind a photographic project is of primary importance to Bendiksen. He is very much a series- and project-oriented photographer, rather than someone who concentrates on the individual image. 'For me, photography is simply a language,' he says. 'If you can identify what you are truly interested in, and use the medium to communicate that, then you have a powerful starting point.' It is the immediacy of the medium that he feels captures the imagination and makes it such a vital communicator. 'At no point in history have so many people engaged with photography as a medium – just look on people's phones and hard drives. You can start engaging with photography within a second or less. Video, literature or music demand specific settings and timelines.' While applauding the technological innovations that have made photography accessible to all (through websites such as Flickr) Bendiksen believes that the important contributions to the field still come from 'the realm of ideas'. He thinks that 'the people who will make a difference with photography are not just the ones with good pictures, but with powerful ideas behind them.'

BELOW
the jewish autonomous region, 1999

OVERLEAF
**a little girl playing in laxmi chawl,
dharavi, 2006**

Bendiksen has already received numerous awards, including the 2003 Infinity Award from the International Center of Photography in New York and the Telenor International Culture Prize in 2008. In 2007, he received a National Magazine Award for his documentation of the Nairobi slum Kibera, which was published in *Paris Review*. His work continues to be featured in *National Geographic*, *Newsweek*, the *Independent on Sunday* and the *Telegraph Magazine*. He is represented by Magnum, and prints of his images have started to find their way on to the auction market in the past few years. Bendiksen is a collector himself and admits he does not have a specific approach when looking to buy: 'I react to something and, if I want to own it, it is because it speaks to me and I think it can transcend a passing moment. I don't collect as an investment or to show off.' By the same token, he feels honoured that collectors wish to own his work although he asserts that 'it is not the reason why I produce what I produce'.

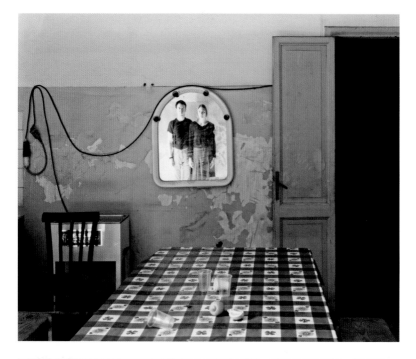

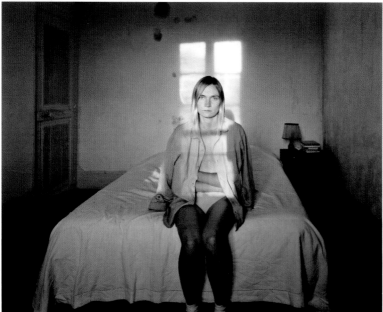

elina brotherus

born: 1972, helsinki, finland

Elina Brotherus is a photographer and video artist born in Finland and now based both in her homeland and in France. Her first experience of photography came as a child: she recalls watching her father develop black-and-white prints in the family bathroom. Only much later, unsatisfied in her career as a chemist, did Brotherus start to explore the possibility of making a career out of her hobby: 'I was looking for something I would really enjoy doing so I applied to study photography at the University of Art and Design in Helsinki – a choice I have never regretted.' Two decades on, Brotherus is still fascinated by the medium: 'Photography still surprises and enchants me... Nothing has changed,' she says.

Describing her photographic style as 'sincere' and 'visual but pared-down', Brotherus has long been pursuing an artistic journey with herself as the main model. Since the 1990s she has appeared as the subject of much of her photography, producing self-portraits as a means of exploring her own experiences in life and love. Using this device, she seeks to examine the emotional landscape of the individual more generally, creating universal themes out of her personal experience. In earlier works these strong emotions were deliberately expressed in as reduced and simplified a mode as possible, with Brotherus acknowledging her use of a particularly 'narrow palette'. In the late 1990s, however, accents of colour began to appear in her work with the creation of the *Suites françaises* series (1999). At the time she was living in France and seeking to explore the landscape of the country as she had done previously in Finland. Many of the scenes from

Suite I are deserted. She did not use herself as a model in the pictures, explaining that 'in this new country I could not find a place for myself in those unfamiliar landscapes'. *Suite II* explores, with some light-heartedness, the photographer's attempts to learn the language of her new country, documenting her use of Post-it notes to learn French vocabulary. Images of paper-strewn interiors reflect her life at that point on a highly personal level, but at the same time the photographer's larger themes remain: landscape, portraiture, still life, the human figure. She also reflects more generally on the instability generated by feeling like an outsider in a certain environment.

While such themes draw Brotherus's work together in a coherent way, she admits that her projects are rarely planned in advance. 'I go out without knowing what I am going to find. It is the eye that decides,' she says. In this way, the initial idea for one of her most recent significant series was sparked by an off-the-cuff comment of a friend and gallery director: 'Photography is the new painting.' With this phrase in mind, she set out to approach the same challenges that painters have long contended with – light, colour, composition, the projection of three dimensions in two – and, crucially, chose large-format colour photography to work on these aspects. The series is called *The New Painting* (2000–4), with the subject matter taken from Brotherus's environment, from the places she was living in at the time, her travels and her companions. As before, the series comprises landscapes as well as studies featuring herself as the model. In these images, however, she sought not to create a psychological or emotional

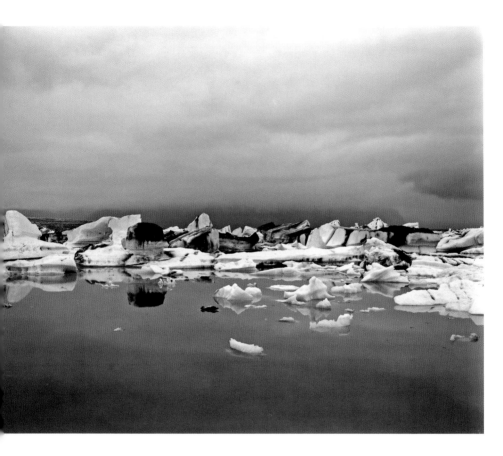

ABOVE
horizon 6, 2000

OPPOSITE
le sommaire, 1999

portrait, rather intending the images to be
investigations into a person's external properties;
she is interested in how the body as 'object'
reacts to its surroundings and how it forms and
re-forms to adjust to the space where it is placed.

Brotherus's mode of expression is important
to her. She takes 'a lot of care when selecting
images and printing techniques'– for more than
ten years she has limited the number of editions
she produces to six, having previously fluctuated
between five and ten, and she has several
standard sizes that she prints to. She is aware

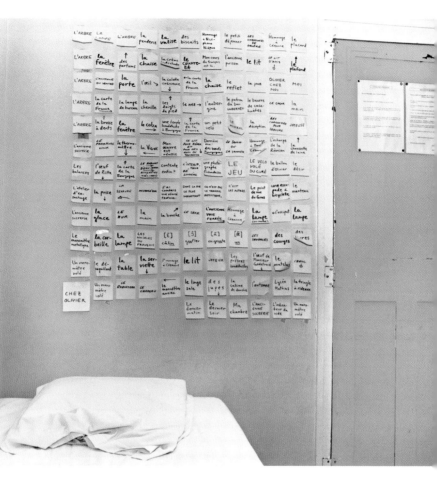

of the importance of choosing materials that
will result in the best preservation possible, and
stresses how important it is for photography
collectors to understand this: 'Pay attention
to and learn about the techniques of print
production,' she advises, 'and take care of
the display and storage condition of the works.'
Brotherus is concerned with the staying power
of her work not just as physical prints but as
images within photographic history. She holds
back one print from each edition she creates,
reserving it for any public institution that might

wish to acquire it, and confesses that the
inclusion of her work in such institutions
means a great deal to her: 'It is the recognition
associated with it that is most important. To be
in a museum collection is like being included in
a long chain of tradition, which provides a sense
of perspective and humility.'

edward burtynsky

born: 1955, st catherines, canada

Canadian photographer Edward Burtynsky has
worked as 'a photographic artist, entrepreneur,
author and lecturer' since the mid-1980s. He
says he fell in love with the 'magic' of black-
and-white photography as an eleven-year-old.
The dominant theme in Burtynsky's work is
nature transformed by industry. This idea has
developed continuously throughout his career,
from the early beginnings photographing the
General Motors plant in the town of St
Catherines, Ontario, where he was born, and
later taking him all over the world from China
and Bangladesh to Australia and Italy. He seeks
out the raw elements of mining, quarrying,
manufacturing, shipping, oil production and
recycling, and turns them into the expressive
pictures for which he has become famous,
showing that beauty and humanity can be
found in all kinds of places.

Burtynsky intends his work to be understood
as a reflection on modern times: he is interested
in the contradiction between man's dependence
on nature to provide materials for consumption
and the environmental effect he has on the
future of the planet. The sites and materials
depicted form Burtynsky's own version of
the classical 'Ages of Man', updated with
contemporary themes. One of the numerous
awards he has received for his work was the
Technology, Entertainment and Design Prize
(TED) in 2005, which prompted him to articulate
'one wish to change the world'. He wanted
to encourage international discussion about
the environment and founded the website
www.worldchanging.com. In the past few years
it has produced more than 10,000 articles and
a book on climate change.

shipbreaking #23 (chittagong, bangladesh), 2000

**rock of ages #1, active section, e.l.
smith quarry (barre, vermont), 1991**

The recycling plants, mines, quarries and refineries that Burtynsky portrays are all places 'outside our normal experience, yet we partake of their output on a daily basis'. Similarly, he sees the medium in which he works as relevant to all people. The appeal and endurance of photography, he believes, lies in the fact that 'we all know a great deal about how to read a photo'. Calling photography an 'inclusive and rich form of sharing human experience', Burtynsky talks of its importance in chronicling our personal lives. A meticulous worker, he conceives of a series in advance, researches it conscientiously and only then begins the actual process of taking pictures. Over time, he says, he has come to understand what makes a great photograph and knows in advance which shots will not survive the editing process. Asked which images he is most proud of he cites his *Shipbreaking* series, shot in Bangladesh in 2000–1: 'The images and the effect they had on my career, and the world, were extraordinary.'

Burtynsky's career is marked by his strong commercial sense. He often works to

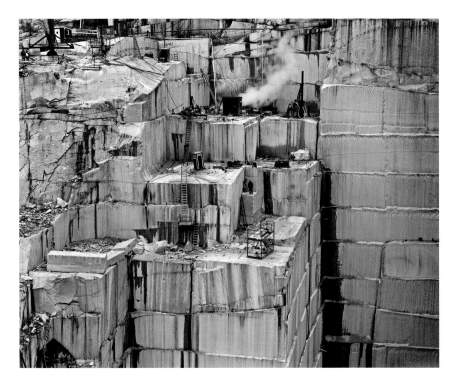

**shipbreaking #4
(chittagong, bangladesh), 2000**

commission, particularly when it fits the theme of his work. He has not hesitated to create a market for his prints, acknowledging that 'without it I could never dream of doing the work I do'. In 1985 Burtynsky founded Toronto Image Works, a centre for digital imaging and new media training where the city's art community can make use of the facilities and rent darkroom space. He lectures widely on photographic art and has spoken at the National Gallery of Canada in Ottawa, the Library of Congress in Washington, D.C., and the George Eastman House in Rochester. Burtynsky's work has appeared in numerous publications, from *GQ* to *National Geographic* and the *New York Times*. His photographs feature in major public institutions around the world such as the National Gallery of Canada, the Bibliothèque nationale de France and the Guggenheim Museum in New York, and he is represented by galleries in Toronto, Calgary, Montreal, New York, London, Barcelona and Cologne.

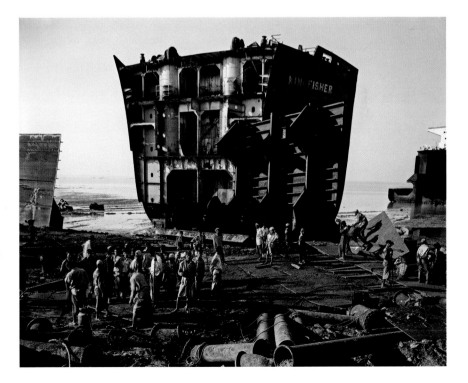

kelli connell

born: 1974, oklahoma city, usa

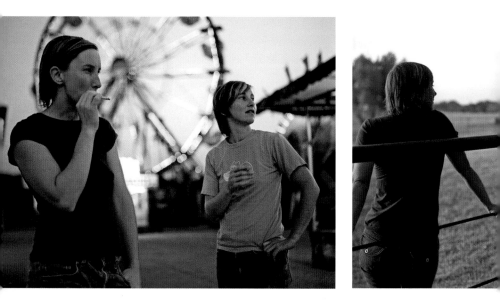

American artist Kelli Connell's introduction to photography came in the summer of 1996 – she recalls: 'As a break from the Texas heat, I spent countless hours lying on the floor of my best friend's apartment poring over piles of photography books.' The friends 'fell in love with, dissected, interpreted and judged' the work of Larry Sultan, Larry Clark, William Eggleston, Diane Arbus, Lee Friedlander and Francesca Woodman, among others. For Connell, the feelings stirred up by these newly discovered images blended with the affection she held for her friend. She admits that 'in truth, I had quite a crush on my friend, and my secret longing seemed to flow into every image that consumed our attention'. The work Connell produces today

continues to connect imagery with personal experience and emotion in similar ways.

Connell describes her photographs as images 'that appear to be documentary in their approach, but are actually highly directed'. She completed her Master's degree in fine arts at Texas Woman's University in 2003 with a body of work called *Double Life*, which won her almost instant recognition. In this series of photographs, Connell constructed an imaginary relationship between two women. Drawing on experiences from her own relationships as well as observations of others', both real and fictional, Connell depicted banal moments in the couple's life such as drinking coffee or eating out as well as more dramatic scenes relating to arguments,

OPPOSITE
carnival, 2006

CENTRE
ponder, 2008

BELOW
convertible kiss, 2002

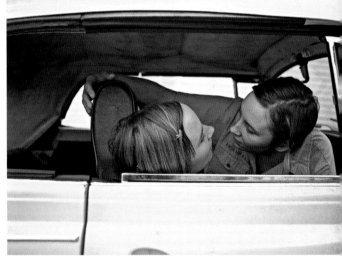

sex and pregnancy. The twist lies in the viewer's realization that the figures in each scene are in fact the same model. Scanning and manipulating two or more negatives with Photoshop, Connell creates realistic, believable images of events that have never occurred. 'I work almost like a choreographer,' she explains. 'I usually have a list of what I want in the images ahead of time.' The compositions are carefully planned in advance, down to the model's expression, and Connell herself will often stand in as a model for the other half of the couple. Ordering cheap chemist prints during the process, Connell cuts these up and assembles them by hand to put together the final composition. Despite this element of planning she admits: 'I do love

chance, so I stay open to other compositions, locations and props while I am working.'

Each photograph in the series is created from a single idea. It is only when the separate elements come together as a collection – in book form or for an exhibition – that a wider narrative becomes apparent. Connell cites *Carnival* as one of her favourite images to date: the cover illustration for her new monograph, this picture highlights the ways in which colour and light can be used to add meaning. 'With *Carnival* I spent a lot of time tweaking the light to create a sense of excitement with a hint of something darker underneath, evoking the feeling that something is about to happen,' she says. The illusion Connell creates of her work being

'straight' documentary imagery acts as the perfect platform for her to comment on deeper notions that interest her. In particular, she is concerned with ideas relating to identity and the self. Her work raises questions about sexuality and gender roles, and explores how these shape our relationships. Her use of one model to portray both parts of the couple hints at ideas of narcissism, the question whether people search for reflections of themselves in their partners, and how being in a relationship leads to some kind of loss of individual identity. Concurrently, Connell explores wider, universal themes of love, passion and companionship. After completing her first monograph, her next project involved photographing her partner.

Connell currently teaches at Columbia College in Chicago, and her photographs are included in several collections across the United States, including those of the Los Angeles County Museum of Art, the Columbus Museum of Art, the Museum of Fine Arts in Houston and the Dallas Museum of Art. Although it does not drive her work, Connell is aware of the importance of the collecting market. 'Part of being a professional artist is participating in the contemporary dialogue around work being made today, and the art economy is part of that discussion,' she says. 'It has been an honour to have people and institutions support my work over time. Their support has been instrumental in having *Double Life* seen by a larger audience.'

reverie, 2006

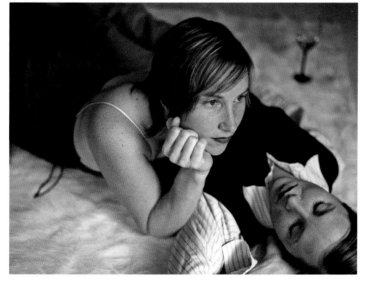

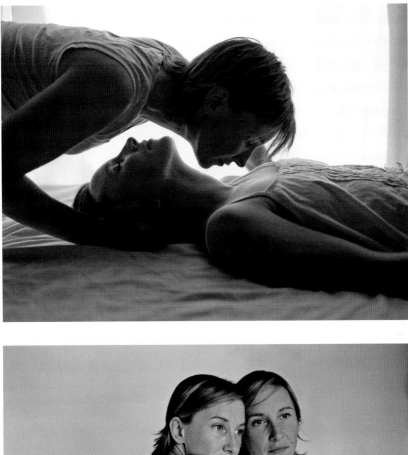

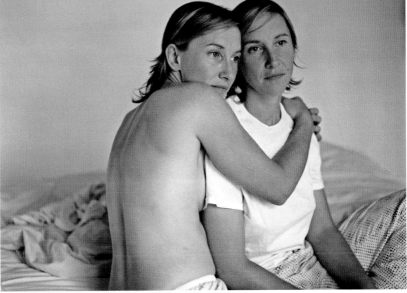

gregory crewdson

born: 1962, new york, usa

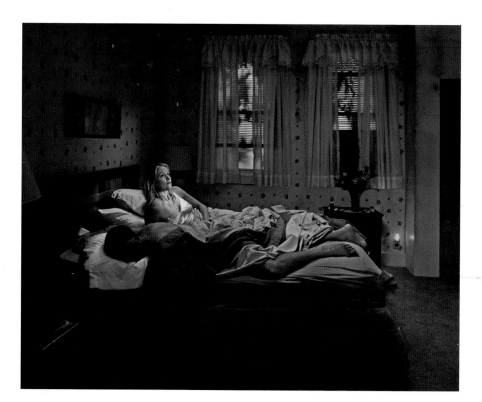

American artist Gregory Crewdson works within a photographic tradition that combines a documentary style with a filmmaker's vision. He operates on a grand scale to create his images, and each of them is meticulously planned and staged. Employing a large crew, the majority of whom come from a film background, he builds elaborate sets, using props, special lighting and actors as models to create his 'frozen moments' – images steeped in detail and narrative content. The shoots can last days, if not weeks, and the resulting images are further refined in post-production. Famous series include *Twilight* (1998–2001) and *Beneath the Roses* (2003–5). In these, everyday settings of American suburbia take on surreal, almost otherworldly qualities. The scenes, often deserted but for a solitary figure or two, demonstrate Crewdson's capacity for clever composition and skilful lighting that suggests

OPPOSITE
untitled (twilight, 1998–2000)

BELOW
untitled (twilight, 1998–2002)

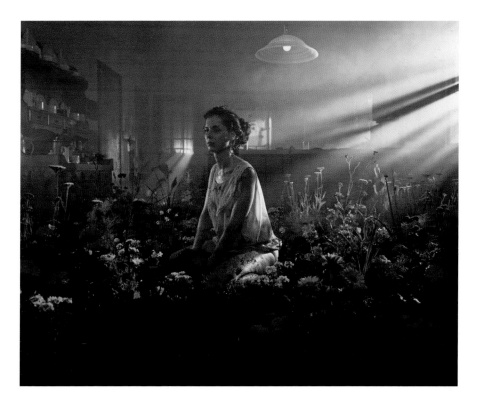

things are not what they seem. The viewer is left with an uneasy feeling, wondering what exactly is going on.

Crewdson came to photography by chance: his intention had been to follow in his father's footsteps as a psychoanalyst, but at university something – or rather someone – got in the way: 'I took a photography class mostly because I had a crush on a fellow student,' he admits. 'And then that fell away and I fell in love with

photography.' His photographic education had begun before then, however: Crewdson recalls his first indication of 'the power of pictures' as a ten-year-old in 1972, when his father took him to a retrospective of Diane Arbus's work at the Museum of Modern Art in New York.

He says he has always been fascinated by the relationship between photography and film, from the earliest images he created, and interested in 'finding a photographic sensibility

OPPOSITE TOP
untitled 2 (sanctuary), 2009

OPPOSITE BOTTOM
untitled (sanctuary), 2009

that hovers somewhere between photographic realism and something more heightened and cinematic,' he explains. 'I am interested in using light and colour as a way of telling a story.' His current method of photographic production 'has evolved over many, many years'.

While technology and methods of production have developed around him, Crewdson feels his views on the medium and his approach to it have changed little during his career. 'Your core vision remains constant,' he says. 'While certain superficial things change, your view of the world never alters.' This view of the world and his way of working, despite being premeditated and structured, nonetheless allow for the intervention of chance. Not everything can be foreseen, he admits: 'There is always an unexpected mystery. It is part of the process of making pictures. Despite the enormous production element, there are necessarily things that go wrong, and unexpected things happen. That is where I think the mystery of photography comes in.'

Crewdson describes his most recent body of work as 'dramatically different' from that which has come before. Acknowledging a need in himself to change tack after his series *Beneath the Roses*, which took eight years to complete, he created *Sanctuary*, first shown in autumn 2010. He explains it as 'black-and-white imagery, more emptied out than my previous work...I wanted to create something on a smaller, more private scale.' Made for the first time outside America, this set of forty-one images was shot on location at the Cinecittà Studios in Rome and is his first black-and-white series since *Hover* (1996–97). It is significant for its minimal reworking in post-production. In these abandoned scenes that are almost entirely devoid of human presence, the film set has become the subject itself of the photograph, no longer just the location.

Crewdson is currently Professor of Photography at Yale University of Arts, where he has been a faculty member since 1993. While he inhabits the academic and practical worlds of photography, as well as the arts and collecting worlds, he tries not to let these different spheres overlap and interfere in the creative process. Crewdson acknowledges an awareness of the collecting market that determines the prices for his work in galleries and at auction, yet he stands firm in the belief that 'you do what is best for the picture first and foremost' without referring to the market that may absorb it.

Crewdson's work is displayed in numerous public art collections, including those of the Metropolitan Museum of Art in New York, the San Francisco Museum of Modern Art and the Victoria and Albert Museum in London. It has also been present on the international auction scene for several years. Crewdson has received a number of important awards, including the National Endowment for the Arts Visual Arts Fellowship and the Aaron Siskind Fellowship.

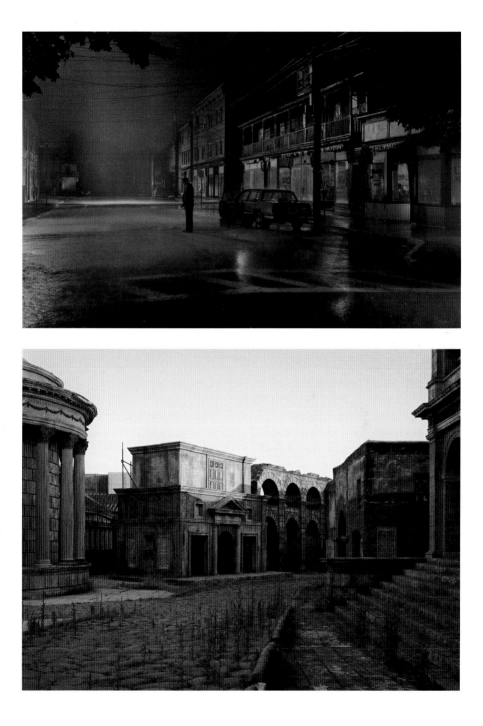

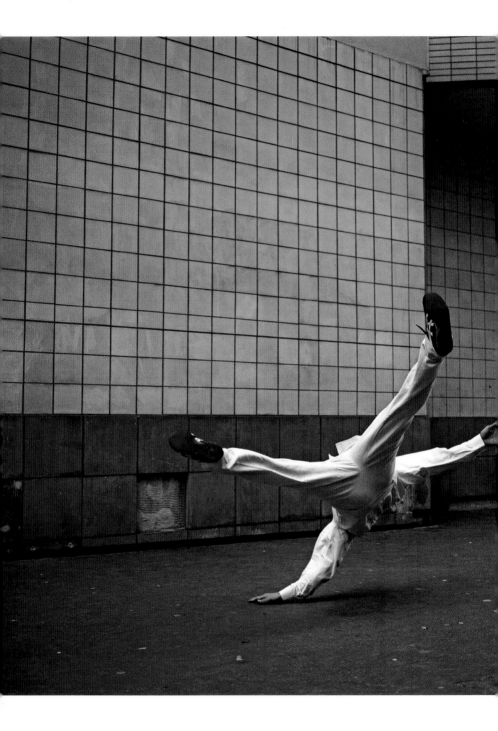

denis darzacq

born: 1961, paris, france

Denis Darzacq has been working as a photographer since the early 1980s, when he became involved in the music scene in France, producing promotional and documentary images. He also worked as a set photographer for feature films by directors such as Charlotte Akerman and Jacques Rivette, but for years now he has explored the gritty streets of his home city of Paris, documenting suburban life in housing estates. He is well known in France – having contributed to publications such as *Libération* since 1989 – but it is only in the past few years that he has started to gain the international recognition he deserves. In 2007, shortly after he received the World Press Photo Award, images from his series *La Chute* appeared in an article entitled 'Down and Out in Paris' in the *Guardian*, and Darzacq's work began to capture the imagination of a wider public.

The idea for *La Chute* was conceived after the Paris riots of 2005, presenting young men and women athletically suspended in mid-air, displaying a degree of discipline that is absent elsewhere in their lives. Having watched hip-hop and break-dancing shows in Paris, Darzacq began to film these displays and freeze-frame the movements to get a sense of the kind of imagery he wished to replicate in his photography. He then took to the streets with these snapshots, persuading young people he met to work with him. Each of his images is

la chute no. 13, 2005–6

taken in one shot, with a manual camera and no digital manipulation. The young people depicted are deliberately expressionless and dressed in unremarkable clothing. With these images Darzacq sought to comment on a generation in free fall, to highlight the alienation of an existence in suburban estates and to bring home his concern that these youths could be left to 'crash to the ground' unnoticed. With his 2007 series *Hyper* (after the French *hypermarché*), Darzacq went a step further, taking the same disaffected youths to supermarket aisles and other places of everyday activity, where their extraordinary ability and energy is contrasted with a mundane background. Produced in large-format colour prints in limited editions, these photographs have great physical presence, complementing the physicality of his subjects.

Darzacq's projects are entirely conceived in advance. He locates the place, the clothes, the movement, everything 'except the experience of meeting the individuals'. One of his most personally fulfilling projects was *Bobigny Centre Ville* (2004–5), a series documenting the individuals and groups and their homes in a community north of Paris. The place is marked by the social and political issues caused by rapid urbanization and immigration after the war, and he talks of the experience as one where he went to meet 'the other' but found 'himself'. It is working with these individuals that shapes Darzacq's projects and drives him to create these particular images. While he does not take on commissions, Darzacq feels that he can reconcile the commercial aspect of photography with his artistic endeavours by employing the same models for both kinds of work wherever possible. He is influenced by contemporary culture and advises new photographers and collectors alike to look to the same source for inspiration and analysis. To him, it is about 'having confidence in one's own judgment and discoveries'.

Although his mid-flight images are not manipulated in any way, Darzacq talks favourably about the innovations brought about by digital photography. It allows, he says, 'for a faster return between the subject matter and the studio, putting ongoing work into perspective. It forces me to think about my work differently.' In fact, he predicts that the medium will be taken over by digital technology, bringing an inevitable decline in traditional processes such as gelatin silver printing, but he has no doubt that photography will endure, in whichever form. It is the 'incredible, complex semantics that give the medium its continual appeal'. For Darzacq, the future is bright, and it is intertwined with contemporary culture and innovation.

la chute no. 1, 2005–6

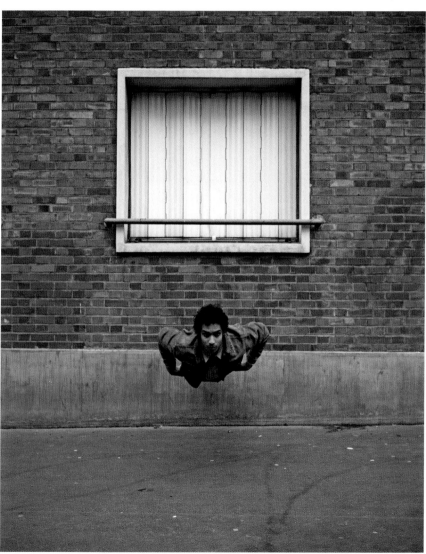

tacita dean

born: 1965, canterbury, uk

British-born Tacita Dean lives and works in Berlin, having moved there in 2000 after receiving an academic exchange scholarship. Trained as a painter, she is best known for her work in 16mm film, although her practice encompasses a variety of media, including artist's books, drawing, sound installation, found objects and photography.

Rather than conventional narratives, her films are portraits of their protagonists. Dean herself often uses the word 'fluid' to describe her work, which invokes themes of 'memory', 'loss' and 'longing', with long takes and steady camera angles creating an atmosphere of stillness and contemplation.

A sense of history, of time and place are crucial elements in her work. Since the mid-1990s, Dean has foregone commentary in her films, instead accompanying the scenes with understated soundtracks. Having published several pieces of writing, she also provides her own words as 'asides' to her visual work.

Dean rarely makes stills from her films, preferring to keep the two media separate, but she acknowledges their inherent link. 'Film is "moving photography", so they are connected,' she says. But it is the quality of the two that renders them different in her opinion. 'I do not really make photographic stills from my work because the photograph does not have the

OPPOSITE
**ship of death
(the russian ending), 2002**

BELOW
ice rink (floh), 2001

same quality as film. Film quality is much lower,'
she explains. Working with the process of
photogravure, however, has allowed Dean to
attain a more film-like quality in her photographs.
'Since I arrived in Berlin I have started to make
photogravures with film stills and they have a
much closer connection to the film.'

Dean engages with photographs in many
different ways: 'Sometimes I have used them
in a fictional way with early Photoshop,' she
explains. 'But recently I have painted on
photographs, and I use found pictures a lot.'
Photography exists in her practice as one
element of a larger project – as an archive of
images or a medium on which to draw or

make notations. It is a 'repository of history'
but also functions as the source of a number
of works for the artist. One significant project
involving found photographs is *Floh*. Published
in book form in 2001, it pulls together a collection
of photographs – portraits, holiday snaps,
documents of everyday experiences and
panoramas – that Dean had found in flea markets
across Europe and North America. She has said
that, once the project was complete, she stopped
going to flea markets, afraid she would find
something that 'should have been in the book',
before realizing that there could be no 'final'
version of such a collection, and that one day
it might itself end up back at a market.

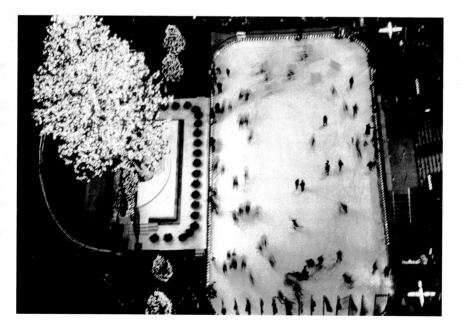

OPPOSITE
detail (czech photos, 1991–2003)

RIGHT
beautiful sheffield (the russian ending), 2002

Dean's 2002 series of works on paper, entitled *The Russian Ending*, reproduces images from found postcards as photogravures, on which the artist then made annotations. The iconography is melancholic, including scenes of funerals, explosions and shipwrecks, and it references the early 20th-century tradition among Danish filmmakers to create two endings for each film, a happy one for the American market and a tragic one for the Russian audience. The 2000 series *Czech Photos* again salvages existing images, this time from Dean's own material, developing and printing a forgotten reel of black-and-white film taken in Prague ten years earlier.

Dean is at pains to avoid being classified as an artist working with photography, preferring instead to concentrate on the themes and qualities that pervade her work, in whatever medium she may choose to develop it. 'I play with these things the whole time and obviously work with a lot of what used to be called "lens-based media" – photography, film, photogravure – but I am not limited to that,' she asserts. Crucially, her photographic work always centres on series and broad themes, never appearing in the form of one-off images. 'The singular

photographic image does not attract me and I have never worked in that way,' she says. 'But there are no rules, which is important. I do not necessarily set out to make series, but if I discover the images work better in a series I will go that way. It is important to me to be fluid rather than to pre-imagine everything.'

Dean is celebrated as one of the original Young British Artists alongside well-known names such as Jake and Dinos Chapman, Gary Hume, Sam Taylor-Wood and Douglas Gordon. Her work was included in the show *General Release: Young British Artists* at the Venice Biennale in 1995, and she was nominated for the Turner Prize in 1998. Her work has since been exhibited in solo shows at the Hugh Lane Gallery in Dublin, Schaulager in Basel, Tate Britain in London and the Musée d'Art Moderne de la Ville in Paris. Dean was commissioned by Tate Modern in London to undertake the twelfth project in the Unilever Series of artworks shown in the gallery's Turbine Hall from October 2011 to April 2012.

philip-lorca dicorcia

born: 1951, hartford, usa

New York-based artist Philip-Lorca diCorcia studied at the School of the Museum of Fine Arts in Boston and completed an MA in Photography at Yale University. DiCorcia's prevalent theme is the examination of real-life situations and the psychology behind them. Whether the scenes are constructed by the photographer, or take an apparently more spontaneous approach, the mix of documentary and cinematic vision conflates reality with fantasy and makes the viewers question what they see each time. DiCorcia's work was included in group exhibitions in the United States and Europe as early as 1977. In this formative part of his career, from the late 1970s into the 1980s, DiCorcia chose family members and friends as subjects of his photographs, situating them in fictional interior settings. The images, showing for example DiCorcia's brother inspecting the empty fridge for food (below), skilfully pretended to conjure up views of everyday life when in reality they had been consciously put together in painstaking detail as highly constructed tableaux.

Moving from the confines of the staged interior, DiCorcia gained wider recognition with his late 1980s/early 1990s series *Hustlers*. Also known as *Hollywood Pictures*, the images were taken along Santa Monica Boulevard in California. The photographer approached male prostitutes and requested to photograph them, asking how much they would charge for their time. He then photographed the subjects in scenes already worked out in advance in great detail. As with his previous work, the careful use of light is central to the process. With the camera on a tripod, he used artificial and flash lighting to heighten the evening light of Los Angeles, creating results that are rich in detail with strong colour in the manner of a Hollywood film still. Each finished image was titled with the

mario, 1978

**brent booth; 21 years old;
des moines, iowa; $30, 1990–92**

subject's name, place of birth and the amount
paid for the sitting. In this way the series
cleverly raises questions about its subjects: are
they the manipulators or the manipulated, lost in
a cycle they cannot break from?

DiCorcia's major series of the 1990s took him
further away from the staged sets with which he
began, and deeper into a kind of exterior 'street
photography'. For *Streetworks*, he travelled
to different cities across the world, creating
studies of people captured on the street going
about their business. Undisturbed by the
photographer, the subjects are shown on the
train or simply walking down the road. These
images are more purely documentary than
DiCorcia's previous work, but his vision and
skill of composition lend them the cinematic
quality for which he is admired. In his *Heads*
series, DiCorcia again captured people in the
street but this time with a telephoto lens

head #4, 2000

synchronized with lights hidden under scaffolding. As suitable subjects approached and the shots were taken, the shutter speed and focused brightness of the flash recorded great detail on each portrait while blanking out the background. The resulting images show people lost in introspection and the details of their day, but illuminated by a certain 'cinematic glow'.

Personal projects remain at the core of DiCorcia's work – 'I like anything with my son in it,' he says – but he has also worked on many fashion campaigns for famous brands including Fendi, Bottega Veneta, Anne Klein, Armani and Nike. He produced a series of images of pole dancers, entitled *Lucky Thirteen*, again demonstrating his skill for lighting and stage management. After thirty years of working with photography, DiCorcia continues to innovate and act as a source of inspiration not only to his own generation, but also to the latest stars of the contemporary photography scene. In addition he is encouraging new students through his role as

lola, 2004

lecturer at Yale University. He professes to be a little weary of the subject having worked with it for so long, yet one senses that he is still excited by the possibilities it offers, particularly through new technology. Having earlier in his career printed his own images – 'I began by making C-prints in a darkroom with an enlarger' – he now leaves this aspect to others. Today, his negatives are scanned and a digital inkjet print is created as the end result. 'Those are the first truly archival prints produced,' he says. The digital revolution has been significant for DiCorcia, and he clearly believes in its merits. Asked which has been the most important recent innovation in his field he immediately responds: 'If anyone answers anything other than digital, they are lying.'

Since his first solo show in 1985, DiCorcia has been the subject of many solo exhibitions at the Museum of Modern Art in New York, the Centre national de la Photographie in Paris, the Whitechapel Gallery in London and the Museo Nacional Centro de Arte Reina Sofia in Madrid. Prints of his images are held in collections across the world, including those of the Bibliothèque nationale de France in Paris, the Museum of Fine Arts in Boston, the Metropolitan Museum of Art in New York and Tate Modern in London. DiCorcia derives satisfaction from seeing his work collected and displayed: 'I won't be here forever, but the collection might,' he says.

bibliothèque nationale de france,
paris, salle ovale, 2009

ahmet ertug

born: 1949, istanbul, turkey

Turkish photographer Ahmet Ertug initially trained as an architect, studying at the Architectural Association in London. After graduating in 1974, he practised in England, Iran and Turkey. He took up photography in 1972, but although he took many pictures of the street life of the East and West End of London, at that time the medium was simply an instrument to him, a means to record his surroundings: 'I used it like a notebook,' he says. His serious involvement with photography began when he was awarded a professional fellowship by the Japan Foundation in 1979, which gave him a year to explore Japan, to photograph its temples, festivals and vernacular architecture. 'It was an aesthetic feast and

opened a new chapter in my life', he says. In particular, his Japanese training taught him to find 'the perfect symmetrical view' of his subject, which he now does instinctively when capturing something new.

Today, Ertug is celebrated as a photographer of exterior and interior architecture. He seeks inspiration in the 'mystical aura of Istanbul's Byzantine, Ottoman and Roman heritage' and his series include photographs of Byzantine murals, Hellenic, Roman and Buddhist sculpture and, more recently, studies of libraries and opera houses across Europe. He is most proud of this last collection. For these images he used a large-format Sinar camera, because 'it involves a lot of passion to handle this giant camera'

trinity college library, dublin, the long room, 2009

the results are special to him. Ertug's images are physically impressive: large-format (often 220 × 180 cm/87 × 71 in.), saturated with colour and intense in detail. Limiting the edition size to three or five, Ertug seeks to make his photographic prints almost as rare as the subjects they depict. He manages to capture the past and bring it into the present by employing a contemporary means of expression. Ranging from the vast interiors of monumental buildings to the gaze of a single ancient sculpture, his images draw the viewer in to examine the details and explore the cultural heritage depicted. Driven by his dedication to preserve and document history, Ertug established his own publishing house in the 1980s and has published around twenty-five

art books on Byzantine, Ottoman, Hellenistic and Asian art.

Ertug describes the photographic process as a 'meditative instinct' for him. He does not leave his images to chance, preferring to know exactly what he is going to photograph. The camera is placed at a specific point, decided on by instinct, then the image is framed in such a way as to ensure that the whole is used in the finished product. 'I never do any cropping of the 20 × 25 cm (8 × 10 in.) image,' Ertug proudly explains. Perhaps unsurprisingly, he eschews recent technical innovations. While he is impressed by the advances in the high-end digital cameras now available, he believes primarily in more traditional methods and, vitally, in the skill and inspiration of the photographer

OPPOSITE
**bibliothèque sainte
geneviève, paris, 2009**

RIGHT
**bibliothèque nationale
de france, paris,
salle labrouste, 2009**

himself. 'Time has proven that large-format
8 × 10 in. film – with the eyes and knowledge
behind it – is the master of innovation.'

Ertug has held several solo exhibitions in
Paris, and his photographs have been sold at
auction in London and New York. His images
of famous monuments in Istanbul have been
shown in Paris, Madrid and Toronto under
the auspices of UNESCO, while a permanent
exhibition of his photographs of Istanbul's
Hagia Sophia is on display in the upper gallery
of the famous building itself. To a collector
approaching his work, Ertug stresses the
importance of understanding and exploring
the world of photography collecting. He advises
visiting Paris Photo, the world-renowned
photographic art fair held each November since

1995, and he thinks it is equally important to
follow auctions and develop good relationships
with gallery owners and curators. His passion
drives his work and, while he is clearly savvy
about the demands and desires of the wider art
world, he does not think the audience should
dictate his work. 'Every new project develops
my ideas,' he says, 'but the technical and
conceptual aspects of my photographic vision
remain the same.'

julia fullerton-batten

born: 1970, bremen, germany

Julia Fullerton-Batten grew up in a family where, she recalls, 'handicrafts and a general interest in art were always present'. Her father, a keen photographer with his own darkroom, would occasionally allow her to use his camera to photograph her sisters and friends. After college, she developed her interest by assisting 'many of the best photographers in London' for what she remembers as 'five long but rewarding years'. She feels that it was the combination of study with practical training that enabled her to begin developing her own style.

During Fullerton-Batten's tenure as a photographer's assistant, a group of her images taken in Vietnam won a series of awards and led to an agent in Germany offering to represent her,

resulting in her first assignment in Australia; she was soon propelled into a professional career. Today, her advertising clients include big brands such as Sony, Lacoste, Ligne Roset, Canon, Ikea, VW and Visa. Not simply a commercial photographer, however, Fullerton-Batten has exhibited works in the permanent collection of the Musée de l'Elysée in Lausanne and various galleries from China to Abu Dhabi. She has produced work on commission for the National Portrait Gallery, the Royal Shakespeare Company and the Royal Opera House in London. The largest of these projects was for the National Portrait Gallery when she was asked to take portraits of sixteen prominent people in the National Health Service. The portraits were

yellow dress (awkward), 2011

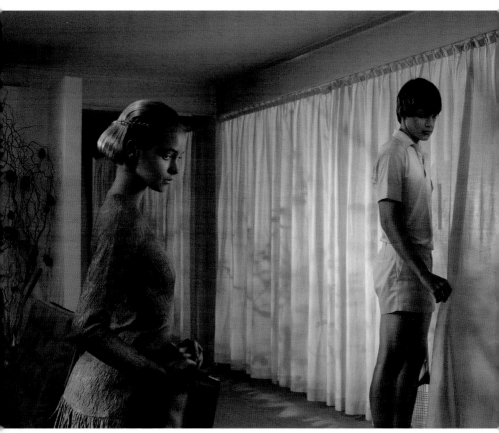

OVERLEAF
hallway (in between), 2008

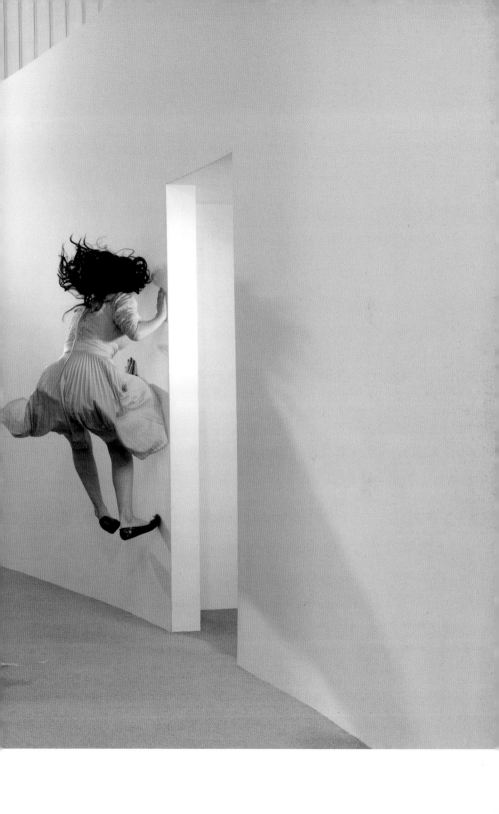

OPPOSITE TOP
eating noodles (school play), 2007

OPPOSITE BOTTOM
library (school play), 2007

displayed in the summer of 2007 and are now part of the permanent collection.

Fullerton-Batten's reputation as a 'fine art' photographer stems from the three-part project about teenage girls that she has been working on for a number of years. In the first of these series, entitled *Teenage Stories* (2005), she depicts adolescent girls in settings such as model villages where they dwarf their surroundings. Published as a book in 2007, these pictures, capturing the tensions of the transition from girl- to womanhood, are those of which she is most proud. 'The images touch my heart,' she says, 'as they are stories of my life as a young girl.' In the 2007 series *School Play*, she explored cultural differences between Asian and Caucasian teenage girls. *In Between* (2009) also covers female adolescence, examining girls moving towards maturity, portrayed literally with the subjects floating upwards in space, the awkwardness of their in-between state evident.

Fullerton-Batten finds inspiration in small things: an episode from her daily life, a scene from a film, a painting or a line from a book. Her process of creating images is rigorous, from sourcing locations and props to booking assistants and make-up artists and hiring lighting equipment, arranging travel details and – crucially – finding models in the street, rather than through casting agencies. The slight awkwardness displayed by the untrained models adds to the freshness of the images and emphasizes the themes of the photographer's

work. By the time the shoot starts, Fullerton-Batten says she knows 'exactly where I want the models to be, how I will light them and what the feeling I want to create is'.

When giving advice to young photographers embarking on their career, Fullerton-Batten takes a practical approach, believing that it is more beneficial to gain hands-on experience through assisting more experienced photographers than doing a degree in the subject. She also stresses the importance of raw passion: 'It is absolutely essential to build a portfolio that you believe presents your work in the best possible way. Make sure its content comes from the heart and is the best you can do.' She adds that belief in one's talent must be combined with a good business sense and the ability to work hard and persevere through the inevitable setbacks. She is aware that in the collectors' market, fine art can be judged by its price tag and concedes: 'If price is the means by which we judge acceptance of an art form, then it is true that photographic images still do not command the same prices as Old Master paintings.' However, she feels that this is changing – 'prices for fine-art photographs are constantly increasing and will continue to do so' – and she is adamant that the medium has found its status as an art form. 'One cannot look back on the works of renowned photographers since Fox Talbot,' she says, 'and not recognize that these images are works of art.'

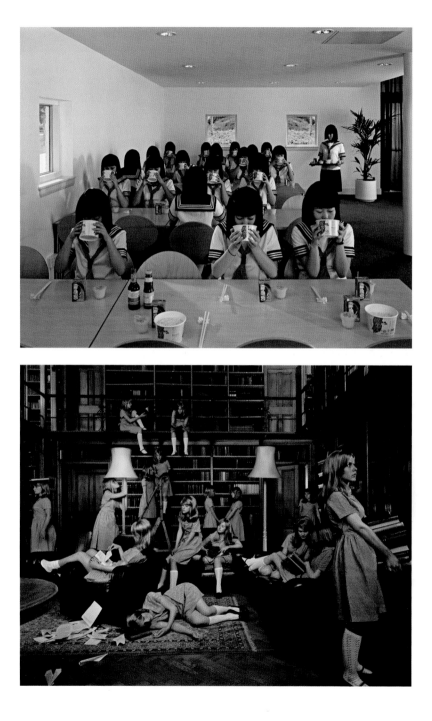

untitled (outside in), 2010

stephen gill

born: 1971, bristol, uk

Stephen Gill first discovered photography as a
teenager, fascinated by wildlife. 'I spent a lot
of time in my early teens photographing birds
and animals as well as playing around with
microscopes,' he says. Inspired by the book *The
Observer's Book of Pond Life*, which he renewed
endlessly at his local library, the young Gill
would sit patiently with camera set up and food
laid out to attract birds. 'It just grew into what
I did,' he explains. 'It was a great outlet for my
excess energy that did not involve breaking the
law.' Gill's father, a keen photographer himself,
taught his son to develop and print his own
pictures in the attic darkroom at their home in
Bristol. While still at school, Gill worked for a
local photographer, and in 1992 he enrolled on a
photography foundation course at Filton College
in Bristol. Working subsequently at Magnum,
Gill developed his interest in documentary
photography and expanded his knowledge of
the medium and its history. He continued to
work on his own projects in his spare time and
in 1997 decided to go freelance. He accepted
editorial commissions, mostly portraits, as a
means to finance his personal work.

 Gill is perhaps best known for his work in and
around the area of Hackney Wick in London's
East End, a place he discovered in late 2002.
Surprised to come across something new in a
part of the city he thought he knew, Gill was
fascinated in particular by the Sunday market
held in an old greyhound-racing stadium. He
bought a plastic camera there for fifty pence,
which had no focus or exposure controls, and
began to photograph with it straight away.
Over the next five years he returned to the area
repeatedly, documenting the great diversity of the

untitled (hackney flowers) 2007

untitled images (coming up for air), 2009

population as a reflection of the multiculturalism of London as a whole. Gill was also drawn to the quieter part of Hackney Wick – its canals, rivers and allotments, home to many forms of wildlife. He started to take images in Hackney Wick two years before London's bid for the 2012 Olympic Games was placed. The later development of these lands for the Games in London, and the associated threat posed to nature, has naturally been a subject of great concern for the photographer. One of his series completed in 2007 is *Archaeology in Reverse*, a study filled with quiet foreboding of the consequences of this rapid transformation.

This was a theme Gill had already begun to develop in a series of photographs called *Buried* (2006), also taken in Hackney Wick. As the title suggests, the prints produced for the series were themselves buried underground for varying lengths of time. He was unsure what to expect on recovering the photographs and the element of chance appealed to him, as did the 'sense of true collaboration' with the place he had become so attached to: 'Maybe the spirit of the place can

how they are part of people's lives. In 2008–9 he travelled to Japan and produced a series of photographs entitled *Coming up for Air* and *B Sides* (2010), a body of work made in reaction to the speed of modern life rather than as an attempt to describe it; the images mute the chaos within a fictional underwater world he has invented. It is a quieter, less forceful way of working for Gill, which he has come to appreciate over time. 'Today I mostly enjoy photography that does not force a point,' he says. 'So often photographs tend to enhance, exaggerate and amplify. I like a picture that is allowed to breathe, letting the subject speak for itself even if its core is not contained directly in the image.'

An important aspect of Gill's output is the publication of his photographs in book format. In 2005 he founded his own publishing imprint, Nobody, in order to have control over the process of publication of his monographs. Gill views the finished books as a continuation of his photographic projects, not just a means of presentation. He enjoys experimenting with formats, materials and printing processes, and on occasion he manufactured books and put them together by hand in his studio. The books have become highly sought-after as collectible objects in their own right. Gill's photographic prints are held in several private and public collections and have been exhibited internationally at various institutions including the National Portrait Gallery and the Victoria and Albert Museum in London, the Sprengel Museum in Hanover and the Palais des Beaux-Arts in Brussels.

also make its mark.' Working with nature, Gill published a series called *Hackney Flowers*, which was also completed in 2007. This time he collected flowers, seeds, berries and other objects from the area, pressed them and then photographed them alongside his own photographs and found objects. Some of these multi-layered creations were also buried, allowing for an additional imprint on the surface of the image.

More recently Gill has produced *A Book of Birds* (2010), focusing on birds in the city and

aneta grzeszykowska

born: 1974, warsaw, poland

Polish artist Aneta Grzeszykowska works with film, photography and sculpture to create work with a strong performance element in which she plays with her own image and identity and, more broadly, with the idea of the human body. She is driven by the concept first and foremost and selects the medium that is most appropriate for the focus of each project, rather than letting it define the work. She came to use photography because at that point in her career 'it was the most adequate medium for the work I was preparing'. Grzeszykowska embraces innovations such as digital technology and Photoshop but does not want to get caught up in the technical details. 'I do not think the technique should change the work. My advice is not to concentrate on the medium itself, but rather to treat it as a language that you can use.'

ABOVE AND TOP
album, 2005 (201 photographs in an album)

untitled film still no. 31, 2006

love book, detail (ana mandieta), 2010

In the 2005 project *Album*, Grzeszykowska worked with more than two hundred photographs from her own family archive, using Photoshop to remove herself from each picture. The resulting images were put together in a traditional-looking family album and the collection was first exhibited in locations chosen for their 'homely', intimate atmosphere, among them a specifically designed space at Raster Gallery in Warsaw and a private apartment at the 2006 Berlin Biennale. This curious form of photographic autobiography, in which the central figure is absent, draws on Grzeszykowska's obsessive interest in absence, disappearance and invisibility – recurring themes in her work. In *Untitled (Portraits)*, from 2005–6, identity is again the focus of the images, but here it is completely fabricated. Influenced by the style and composition of German photographer Thomas Ruff's celebrated series of portraits from the 1980s and 1990s, Grzeszykowska used Photoshop processing tools and existing images to fashion portraits of fictional people. Contrary to expectation, the eighteen individuals in the series, created through imagination and digital manipulation, actually come to life in the portraits and resonate with a powerful illusion of reality.

One of Grzeszykowska's most significant projects to date pays homage to the work of the arch-inventor of her own image, Cindy Sherman. Taking Sherman's 1970s series *Film Stills* as her inspiration, the Polish artist restaged them in present-day Warsaw over the course of one year. The composition of each original image (there are seventy in total) is copied strictly, while the setting, props and clothes were selected locally and reflect modern tastes.

Crucially, the images are all in colour, breaking away from Sherman's use of black-and-white, thus bringing the series up to date and inviting the audience to re-examine the material. In the performance process, Grzeszykowska practically erases her own identity, taking on that of the American photographer whose work she is emulating, as well as traits of the individual characters in the film stills she is replicating.

Since 1999, Grzeszykowska has worked in collaboration with the artist Jan Smaga. Together, the Polish duo have created works such as *Plan* (2003), a series of ten photographic compositions showing details of ten apartments shot from above, as if the ceiling had been removed. This simple format belies a complex production process: each picture is created from dozens of fragments merged with the use of computer technology. The resulting level of detail in the composition is extraordinary, and the resolution is extremely high. A sociological document as well as an intimate portrayal of everyday life, this work-intensive project took two years to complete.

Grzeszykowska has been showing work in group exhibitions since 2002 – her own projects as well as those made in collaboration with Smaga. Starting with exhibitions in her home country, her network has now spread to other European cities – Strasbourg, Milan, Brussels, Amsterdam and Barcelona among others – and further afield to the United States, specifically the Robert Mann Gallery in New York. She is fast gaining recognition and praise from the photographic and wider art community.

sunil gupta

born: 1953, new delhi, india

Sunil Gupta's photographic and video work travels between East and West, reflecting the journey of his own life. Born in New Delhi in 1953, he moved to Canada as a child and first discovered his talent for photography while studying for an MBA in New York in the 1970s. This was a pivotal time in the market for fine photography, with an explosion of photographic galleries and auction sales, and Gupta attended a workshop with the photographer Lisette Model. She advised him to interrupt his MBA studies and take up photography. He followed her guidance, and by 1983 he had moved to London to study for an MA at the Royal College of Art. During this period he helped found Autograph, the Association of Black Photographers, a charity that works to bring photography to an international audience with a particular emphasis on cultural identity and human rights issues.

Inspiration for Gupta's photographic projects comes from cinema, literature, the news and 'the myriad details of my own lived experiences'. Using large-format colour photographic prints, Gupta communicates to his audience the details and overarching theme of a life split between East and West. His 2000–3 series *Homelands* is particularly autobiographical, created at a time when he was based at the University of Southampton as a research fellow. Gupta chose cities that had been his home over the years – Montreal, New York, northern Delhi and London – and, as an HIV sufferer, sought to comment on his status and the world around him through the

chelsea, new york/albert embankment, london (homelands), 2001–3

humayun's tomb (exiles), 1986–7

pavitr (mr. malhotra's party), 2007

images taken in these places. He says he is most proud of his 1986 project *Exiles*, however. This series was born out of the observation that much traditional art history centres on Western iconography, or as he puts it: 'Art history seemed to stop at Ancient Greece and never properly dealt with gay issues from another place.' He felt it was imperative to show contemporary images of homosexual Indian men, and he was able to realize this ambition when he was awarded a commission by the Photographers' Gallery in London to document the experience of gay men in Delhi.

For Gupta, photography is the obvious choice of medium to communicate his ideas. Its 'realism and ease of technicality' appeal to him; he sees it as 'accessible to everyone' and in fact as one of the most important media of the 20th century, with 'its own history and trajectory in the world'. He welcomes the way in which 'chance plays a role in photography' and therefore plans his series only in terms of choosing locations and participants. 'Things happen on the spur of the moment', and he prefers it that way. Gupta foresees a bright future for photography, one in which it expands into 'an exploration…outside the American and European canon'. He already sees a growth of interest in Latin American, Asian and African photography and feels confident that these images are reaching new audiences and finding

their place in the history of photography. Gupta believes that the printed photograph is key to the future of the medium and that people are passionate about it. Alongside the continual innovations in digital technology, which allow for 'a whole new way of arriving at the print', he feels that we are witnessing 'a swing back to the craft of producing photographic prints'.

Although he sometimes produces work on commission, Gupta sees photography as 'sitting uneasily' with commercialism. 'A picture taken for a client is necessarily subscribing to that client's world view,' he asserts. Advising young photographers at the start of their career, he recommends focusing on one's own ideas rather than thinking about what the market might call for. Nonetheless, Gupta's work has already found its place in the collecting market, and his photographs have been exhibited at Tate Modern in London, the Canadian Museum of Contemporary Photography in Ottawa, and Bombay Art Gallery in Mumbai, among numerous other places. In addition, Gupta has taken on the role of curator on numerous occasions, in 2008 at Vadehra Gallery in New Delhi for the exhibition *Click! The Indian Photograph* and recently at the Whitechapel Gallery in London, for the 2010 show *Where Three Dreams Cross: 150 Years of Photography from India*.

blast #13009 (a bird), 2006

naoya hatakeyama

born: 1958, iwate, japan

Naoya Hatakeyama has been producing photographic work that concentrates on man's relationship with his environment since the 1980s. People rarely feature in the photographs; it is rather the marks of human intervention on the landscape that are highlighted. In Hatakeyama's first two major series, *Lime Hills* (1986–91) and *Lime Works* (1991–94), he photographed the workings of lime quarries. The resulting large-format colour prints document the systematic stripping away of hillsides and display an apparent calmness that does not force a particular position on the viewer. He describes his style as 'disengaged', and yet one senses that he is drawn to the places he photographs and to the change and destruction he witnesses there.

In the series *Blast* (1995), Hatakeyama develops this earlier theme to show the destructive side of the mining process in more detail, capturing debris flying from the mountainside where explosives have been laid. The force of the explosion is felt in the trajectory of the rock splinters, frozen in mid-air; and the colours of the clay and stone contrast with the blue of the sky, constituting a scene of natural beauty even within the process of destruction.

The theme of human impact on landscape is further explored in *Untitled*, a series of photographs of Tokyo, where he now lives and works. The urban environment fuels his continued interest in the relationship between nature and the city. Shot from vantage points such as Tokyo Tower, the images explore the topography of the city – sprawling and organic, yet ordered and artificial. Also a noted architectural photographer, Hatakeyama has

ciel tombé #4511, 2007

explored modern civilization in the river and tunnels that lie beneath the district where he lives in Tokyo: the man-made tower blocks overshadowing the river are contrasted with the dark and ominous tunnels.

These two bodies of work, *River* and *Tunnel*, were originally conceived separately in the late 1990s, but they were published together, in acknowledgment of their inherent connection, as *Underground* in 2000. The process of creating series with a coherent message is important to Hatakeyama. He stresses the need to 'have a few important images in mind' before commencing work on a project and talks of his enjoyment in 'seeing the dialogue between image and material', which for him is 'the reality of photography'. He acknowledges a shift in his approach that has happened over time as he

realized the impact an individual image can have outside of a series, and how 'the reality of photography is changed accordingly'.

In his diverse subjects Hatakeyama's overarching theme of man's appetite for expansion remains constant. His dedication to the subject was recognized in 2009 when he was shortlisted for the Prix Pictet, which champions work that explores issues of sustainability. Hatakeyama was also invited to represent Japan at the 49th Venice Biennale in 2001. Prints of his images are held in public collections across the world, including the National Museum of Modern Art in Tokyo, the Museum of Fine Arts in Houston, La Maison Européenne de la Photographie in Paris and the Victoria and Albert Museum in London.

tracing lines/yamate-dori #3418, 2008

bill henson

born: 1955, melbourne, australia

Bill Henson's photographic images have been variously described as cinematic, painterly, seductive, surrealist, moody and soft. They are often said to recall a romanticism linked to the genres of literature and painting, and painting and drawing were in fact early influences for the artist when he was growing up in Melbourne. 'I had always drawn and painted compulsively', he says. It was on the strength of his painting portfolio that Henson won a place on the Visual Arts and Design course at Prahran College of Advanced Education in the mid-1970s, but in many ways his ideas and his work had already moved on by the time he enrolled. 'I was gradually finding that painting was falling short of fulfilling something inside me and I became interested in photography. I had started playing

around with a camera and taking photos when I was at secondary school. But by the time I got into Prahran College at the age of seventeen, I was completely fascinated by photography.' After a year he transferred to a photography course, but never completed it. While he was working 'obsessively' on his imagery during this period, his attendance and academic record began to suffer. Eventually, recognizing his talent, his tutors advised him to leave the course to concentrate on his own work, but not before initiating discussions with the curator of photography at the National Gallery of Victoria, which led to Henson's first exhibition there in 1975, at the tender age of nineteen.

Henson's fascination with the medium has not waned in the intervening years, yet he acknowledges that it is first and foremost a vehicle for expression for him, rather than the driving force of his creativity. 'Although I am more than ever fascinated by and engaged with photography as a medium I am simultaneously saying to myself "It just happens to be photography". I took it up because it did not fall short as other media did for me.' He is intrigued by what he describes as photography's 'profoundly contradictory' nature, as a medium of 'evidentiary authority' that audiences instinctively expect to 'tell the truth', but one that can also easily 'skip lightly over that to produce something that is abstract or renders the subject universal in a way that the best music and literature and painting can do'. Henson does not intend for his photographs to act as authoritative evidence – it is this capacity for leaving questions unanswered and suggesting endless possibilities that he enjoys

OPPOSITE
**untitled 24/48
(paris opera project), 1990–91**

BELOW
untitled, 1994–95

TOP
untitled #2, 2009–10

ABOVE
**untitled 28/77 (paris
opera project), 1990–91**

harnessing, leaving the viewers to fill in the gaps and imagine their own narrative.

The main focus of Henson's work is youth. Seeking out remote locations such as urban wastelands and barren landscapes, he photographs androgynous models with a telephoto lens that keeps him at a distance from the scene. Starting with snapshots of ideas – which he describes as 'the stuff circling in the backs of our heads' – he says he usually has a clear idea of what he is looking for, 'although I am not always sure I know what it is going to look like until I see it'. Directing his models with 'millions of wooden instructions' he nonetheless often sees the process changing before his own eyes, as his directions are interpreted by the subjects. 'You almost feel you are along for the ride and the process it greater than you can fully understand or see,' he says. Henson is continually drawn to exploring youth as a particular time of human experience, what he describes as a 'floating world of potential': the time in a person's growth – emotional,

psychological and physical – that leads to a 'spiralling change' and sense of 'instability'.

Much has been written about Henson's use of light in his images: he often shoots in the twilight hours when forms blur and the resulting image plays to his desired aesthetic. 'It is often what goes missing in the shadows that animates speculation, rather than any detail in the highlights,' he explains. 'Of course light is all you have – it is being reflected from the surface of objects, so it is everything. But leaving it out here and there often lends the image more potential.'

Since his first exhibition in 1975, Henson has shown his work in group and solo displays at venues across the world, including the Bibliothèque nationale de France in Paris, the Solomon R. Guggenheim Museum in New York, the Museum of Modern Art in Vienna, and most major museums in Australia. While gallery shows have in the past been criticized over Henson's use of young models, he seems largely untroubled by this, welcoming all kinds of responses to his work as evidence that it has, if nothing else, made his audience think.

untitled #84, 2000–3

zhang huan

born: 1965, anyang, china

Zhang Huan is a Chinese performance artist who has made an impact on the contemporary art scene from the late 1990s onwards. Originally trained in fine art at the Central Academy of Fine Arts in Beijing, Huan felt limited by the medium of painting, choosing instead to bring his subject matter alive by using his own body. His performances are informed by personal experience and require a highly focused mind, as the artist puts his (usually naked) body through extraordinary feats of endurance. He was first drawn to photography when he invited photographers to capture his early performance work, and now documents all his own performances using video and large photographic prints. The latter form a significant part of his output and a tangible record of the artistic process. 'Every work is a record of my feeling at that time,' he says, and as a means of 'viewing, observing and recording the world', Huan sees photography as unequalled.

A member of the Beijing East Village group of artists, who devote themselves to social issues, Huan first gained notice for his performance 'Twelve Square Meters' in 1994. This project was closely related to his own experiences of public toilets in rural China: he decided to stage a performance about the relationship between his body and the flies he found there, coating his skin with a paste of fish and honey to attract the insects. He sat motionless on the toilet for an hour, allowing the flies to cover him, and has described the performance as a mind-purifying experience: 'Life seemed to be leaving me far in the distance. I had no concrete thought except that my mind was completely empty. I could

only feel my body... The very concept of life was then for me the simple experience of body.'

While for Huan 'the most important thing is catching what you want to express deep inside', a number of his performances also touch upon the broader political and social issues facing his country. In 'To Add One Meter to an Anonymous Mountain' (1995), for example, he created a performance with several models lying naked on top of each other in the countryside. The performers' faces cannot be seen as they represent anonymous figures in society and act as a reminder that identity and individuality remain important issues for the populous nation of China. In his other creations, however, Huan's work is more autobiographical. In *Foam* (1998), for instance, his performance is recorded in a series of eleven photographs in which the artist literally offers an oral history of his life, covering his face with soap so that only his mouth is visible and expelling a snapshot of himself as a baby with his mother, followed by other family shots.

Like many artists of his generation in China, Huan is influenced by modern Western art history, together with strong aspects of his own culture, and he has sought to make his work appeal to Western collectors as well. He is one of a select group of Chinese contemporary artists who have conquered the Western art market in the last decade. While less established and perhaps less promising artists have had limited success in the collecting market in recent times, Huan has secured his place on the contemporary art scene. His photographic work has appeared in international auctions for several years now and is held in the

family tree (detail), 2000

½ (detail), 1998

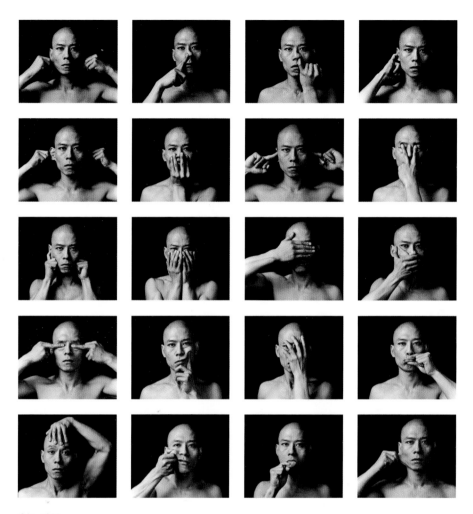

skin, 1998

collections of the Museum of Modern Art and the Metropolitan Museum of Art in New York, the Pompidou Centre in Paris, the Saatchi Gallery in London and the Shanghai Art Museum, among others. Huan says the thing he values the most is 'a feeling of freshness and curiosity', which is clearly the driving force of his performances.

woman reading possession order, 1997

tom hunter

born: 1965, bournemouth, uk

Tom Hunter has the honour of being the first photographer to have been exhibited at the National Gallery in London. From December 2005 to March 2006, photographs from his series *Living in Hell and Other Stories*, consisting of sixteen large-format colour prints, were shown to great acclaim. The series, like much of Hunter's work, is centred on the community of his neighbours and friends in Hackney, East London. The photographs were inspired by the visual language and forms of Old Master paintings, including works by Velázquez and Caravaggio. It was this link that prompted the National Gallery to stage a new exhibition that would reflect on their permanent holdings. More than just updated versions of classical paintings, Hunter's images from this series play with their sources. This experimentation is also evident in Hunter's previous work: *Woman Reading Possession Order*, taken from his 1997 series *Persons Unknown*, is a powerful modern interpretation of Vermeer's *Girl Reading a Letter at an Open Window*.

Hunter's relationship with East London and Hackney in particular is profound. He left school aged fifteen and moved to Hackney just over five years later. Responding to the world around him, he first came to photography when searching for a way to 'talk to an audience about our environment'. The importance of story-telling for conveying this message is evident in his work, but Hunter identifies photography's strong connection with reality as the factor that allows him to create art 'to index the real world'.

**murder: two men
wanted, 2003**

the way home, 2000

Hunter refuses to tell of which project he is most proud and only answers 'the next one', hinting that he is always planning ahead. For *Living in Hell and Other Stories*, he took sensationalist headlines from his local paper, the *Hackney Gazette*, and had his sitters re-enact the stories to create cinematic stills of the action. With headlines such as *Gang-Rape Ordeal*, *Naked Death Plunge* and *Lover Set on Fire in Bed* as titles, these photographs uncover the often disturbing drama taking place within everyday existence. They underline the capacity of the media to stir up feelings of fear and paranoia but simultaneously generate a desire to read the story. Another series, *The Ghetto*, shot in Hackney in 1993–4 and taking its name from an article describing a certain area as a 'blot on the landscape', was part of a campaign to save the community from developers. Fourteen years later, Hunter is proud to proclaim that the same community is still there and at the heart of a thriving neighbourhood.

In addition to his work for the National Gallery, Hunter has produced commissioned work for the Geffrye Museum in London and the Museum of London, and his work has been shown nationally and internationally for many years. He was awarded the John Kobal Photographic Portrait Award in 1998 and an Honorary Fellowship of the Royal Photographic Society in 2010, and he is currently Senior Research Fellow at the London College of Communication.

nadav kander

born: 1961, tel aviv, israel

The winner of the Prix Pictet and International Photographer of the Year in 2009, Nadav Kander was propelled into the limelight seemingly from nowhere. In truth, he has been working with photography for more than thirty years and in this time gained international recognition from his peers and the photographic community at large. Born in Israel in 1961, Kander first came to photography as a thirteen-year-old living in South Africa, when he was given a camera. 'I think it was one of the first things in my life that I excelled at,' he says of photography, 'so I took it up more and more seriously, and it just became a part of me.'

Kander's work is distinctive for its cool, distanced perspective. There is a sense of quiet unease pervading his images, which, Kander acknowledges himself, has been there since he took his first shots in his teens. He recalls a family trip to Europe at the time and the enjoyment he took in slipping out of the hotel to wander around, feeling himself in the shadows looking out at the world. This 'viewer distance' remains. 'I have always known without realizing that the eye needs only to see a fragment and the mind will fill in the rest,' he says.

Kander's projects have taken him to the Ukraine, Japan, Jordan and recently to China to trace the course of the Yangtze River. It was for this body of work – extraordinary in its subtle commentary on the life of the Yangtze people and their landscape – that Kander was awarded the Prix Pictet. *Yangtze* is one of Kander's favourites among his body of work – he is

yibin III, sichuan province, 2007

kindergarten, golden key, sleeping room, pripyat, 2006

drawn to China by what he calls the country's 'unnatural speedy pace', and sees in the river 'a perfect metaphor for constant change'. Kander's approach to his projects is personal in the way that he 'feels' his environment and responds to it. He seeks to distance himself from the idea of 'an intellectual who thinks of a project and photographs following the concept. I never want to photograph thinking about what others might feel about it.' His advice to anyone starting out as a photographer is to 'do it from

your body…and not be too concerned about fashions and how your work will be received'.

Kander has also made savvy commercial choices. In late 2008, he accepted a commission from *New York Times Magazine* to take a series of portraits of Barack Obama and his administration as it was being assembled. Entitled *Obama's People*, the fifty-two portraits, which include high-profile figures such as Hillary Clinton and Joe Biden alongside Obama's personal aide Reggie Love and special projects

**atlantic ocean I (copacabana beach),
brazil, 2001**

coordinator Eugene Kang, were reproduced in the magazine's January 2009 issue, two days prior to the inauguration. It was the first time that a publication had devoted an entire issue to such a project since *Rolling Stone*'s 1976 celebration of America's bicentennial election campaign with Richard Avedon's series of portraits, *The Family*. Kander recognizes the parallels with Avedon's work in his project. However, while this may have been the reference point for the *New York Times Magazine*, Kander says he tried hard not to focus on this precursor, acknowledging its presence but not allowing himself to be overly influenced: 'I specifically did

**field II (ford dealership),
usa, 2001**

not look at it.' His intention, like Avedon's, was 'to make something that would not date too terribly'.

Kander professes himself an admirer of the work of photographers as diverse as Bill Brandt and Jeff Wall, but also says that 'in a way painting has been more important to me', citing Lucian Freud and Francis Bacon as key influences. For Kander, the medium of photography is able to hold its place alongside other art forms without any doubt. While he admits to having seen photography as a 'craft medium' in the past, he believes passionately in its transformative abilities: 'I think it has changed everything.'

izima kaoru

born: 1954, kyoto, japan

Tokyo-based photographer Izima Kaoru is best
known for his ongoing series *Landscapes with
a Corpse*, which he has been working on since
the early 1990s. The project began as a regular
feature in the progressive Japanese fashion
magazine *Zyappu*, where Kaoru was editor-in-
chief until it closed in 1999. Called *Serial Murders
of Actresses*, it showed elaborate scenes of
imaginary murders of various well-known
Japanese actresses dressed in designer clothing.
It is this theme that Kaoru has continued to work
and expand on since, making a name for himself
as the ultimate chronicler of beauty in death.

It is an ongoing series, yet the different
episodes appear as individual, independent
projects, each with its own unique aspect,
capable of standing alone while also contributing
to Kaoru's overarching theme. Each 'death'
comprises a series of four or five shots from
different angles and perspectives – from aerial
and panoramic views to close-ups – as the
camera sweeps the scene before homing in on
the exact location of the body and the glassy
expression on the model's face. Read in reverse,
Kaoru also invites his audience to draw back
from the immediate focus of the corpse to take
in the wider scene, until the presence of death
is barely noticeable. He works closely with the
protagonist in each instalment, inviting the
actress to compose her 'ideal death' and select
a fashion designer and outfit. It is a collaborative
process – 'my work fundamentally needs
contributions from a third party' – and Kaoru
acknowledges the planning and thought that go
into the construction of each scene: 'I conceive it
in advance again and again, and then I think it
over after the shoot, again and again.'

ua wears toga, 2003

Kaoru's death fantasies draw on a long tradition of similar, romantic themes in Japanese art, literature and theatre. The level of detail and styling in each scene betrays the photographer's fashion background, but at the same time the subject matter invites comparison with forensic and erotic imagery. Not simply 'objects in death', however, the models in Kaoru's landscapes assert their personalities through their individual input. Over the course of the project, the photographer's personal choices have also contributed to a shift in his aesthetic: the early images show a clear Pop sensibility, while many of the recent works are more restrained, with a subdued palette only occasionally punctuated by a flash of colour. During his career Kaoru's views have changed from 'making what I want to show others' to 'making what I myself want to see', he admits. He accepts commissions, and acknowledging the huge production costs, he is grateful for 'cooperative offers, both physical and financial'. *Tanja de Jager wears Christian Dior* (2002), for example, was created as part of a film made in Luxembourg, sponsored by the Musée d'Art Moderne Grand-Duc Jean (Mudam). A set of images is now housed in its collection.

Kaoru's photographic prints are produced in large format (up to 150 × 200 cm/59 × 79 in.) in limited editions of five (or sometimes seven or ten) and can be acquired either individually or as a complete set. While he does not appear to place much importance on it, Kaoru is clearly aware of the collecting market, acknowledging that limiting his prints to numbered editions complies with an apparent 'rule' of the market. The reception of his work is important to him, and its inclusion in public and private collections fuels his desire to continue creating images: 'I create because I want to say something to others. Therefore the fact that my work is looked at and makes people feel something is my driving force.'

After years of exploring death and his own feelings about it, Kaoru has in recent years turned to the natural world – the sun in particular – almost as a kind of solace. In the series *One Sun* (see above) Kaoru travelled across the world, making a number of stops to take photographs that followed the path of the sun from its rising to its setting. Leaving his shutter open throughout the day he captured 360-degree views of the sun's progress in the sky. The results are unusual in scale and format, circular in shape and set within a round frame, reflecting the source of the image. The images are bold and graphic, and on closer inspection reveal signs of human existence at the edge of the circle, in the cities and landscapes.

untitled (the eyes, the ears), 2005

rinko kawauchi

born: 1972, shiga, japan

Rinko Kawauchi is fast becoming one of the most successful Japanese photographers of her generation. While studying graphic design at Seian Junior College of Art and Design in Shiga, she discovered that she enjoyed the weekly photography class more than the other design classes, and in 2001, she released three photography books to international acclaim: *Utatane*, *Hanabi* and *Hanako*. Within a few years, three more were published: *Aila* (2004), *Cui Cui* (2005) and *The Eyes, The Ears* (2005). Much has been written about the importance of photobooks in the development of the photographic aesthetic in Japan, and the book format is ideally suited to Kawauchi's fluid approach to photography, allowing her to arrange the images in sequences so that connections and contrasts can be established between them.

Kawauchi describes her images as 'capturing the small moments and details of everyday life'. She achieves this effect by using a subtle colour palette, and the result is characterized by a lightness of touch. A clean, clear light often permeates her work. Attention to detail, texture and composition reveals Kawauchi to be a sensitive photographer; her themes of family, nature and the cycle of life are quite personal. Each image is created without a preconceived concept: 'Usually I think about the concept after shooting,' she says. It is in post-production that things crystallize: 'After I take a photograph it is not all done – I continue to work on it.' The editing and presentation of her images in series is an important aspect of her work, as borne out in her prolific publishing output.

Kawauchi asserts that her technical skill has developed gradually. Having previously worked only with negatives, she now uses both film and digital, acknowledging the advantages of both. She continues to print all her own work on paper sizes up to 25 x 20 cm (10 x 8 in.) and works in close collaboration with a printer for larger images.

Kawauchi's personal favourite among her work to date is her first photography book, *Utatane*. 'I can see the most intense essence of my photography in this book,' she explains. She has also said that her own presence as the creator of the images is 'almost invisible', an ambiguity she relishes. *Cui Cui* is often described as the most personal of Kawauchi's projects, with imagery relating directly to the photographer's own family. Taken over thirteen years, the pictures in the series provide an intimate insight into daily life and significant family events: birth, marriage and death alongside mundane, quiet moments of inactivity and meditation. Originally exhibited as a slide show, the photographs were accompanied by a soundtrack of birdsong and nature sounds, reflected in the title of the series. The atmosphere allowed the viewer to enter a state of quiet contemplation as the images invited reflection on the human condition.

In addition to these personal projects, Kawauchi regularly takes on commissions: for the Museu de Arte Moderna in São Paulo, for example, she was invited to put together a project to commemorate the centenary of the arrival of the first Japanese immigrants in Brazil. Kawauchi made three trips to Brazil and captured the lifestyle of the Japanese immigrant

untitled, (aila), 2004

untitled, (utatane), 2001

communities, observing their strict preservation of the customs and festivals of their homeland. The series also explored Brazilian festivals and captured the landscape in the kind of poetic detail for which the photographer is now well known. In 2010, Kawauchi was invited by Martin Parr (pages 148–51) to exhibit works at the Brighton Photo Biennial alongside photographers Alec Soth (pages 166–69) and Stephen Gill (pages 82–85). Her work is held in many collections worldwide, including the Museu de Arte Moderna in São Paulo, the Tokyo Metropolitan Museum of Photography, the Fondation Cartier pour l'Art Contemporain in Paris and the Huis Marseille in Amsterdam.

idris khan

born: 1978, birmingham, uk

Idris Khan is a young British artist originally
from Birmingham and now based in London,
best known for his ongoing series entitled
Every..., in which he appropriates other forms
of art and culture – images, text or musical
manuscripts – and creates a single image
from these multiple layers. The material he
has chosen to date includes every page of
Roland Barthes' seminal text *Camera Lucida*,
the score of every Beethoven Sonata, every
page of the Qur'an and all images from
German contemporary artists Bernd and Hilla
Becher's series of gas holders. The material is
photographed sheet by sheet, then the separate
images are digitally super-imposed. Areas of
light, shade and opacity are accentuated and
adjusted to create a single composite image
that is blurred yet solid, comprised of translucent
parts. Khan asserts that the finished results
'hardly resemble a photograph', but says that
his work is minutely planned: 'I become
obsessed with the music or art that I want to
appropriate and start to have a composition
in mind.' With such a complex process of
production, the final result often remains a
mystery until the end; Khan says that 'the only
thing that is not conceived, and of which I have
no idea of the outcome, is the number of layers
I will use and the density of the piece'.

Modern technological advances are crucial
for Khan's work, large-scale scanners and
Photoshop being two key tools for his work. The
latter, in particular, has given photographers
great artistic freedom, in his opinion: 'Photoshop

paradise lost, 2010

OPPOSITE
**caravaggio...
the final years, 2006**

has allowed me to create an image that could never have been done before,' he says. He talks of photography's 'battle with painting' and sees large-scale printing and digital technology as having enabled photography to compete with painting in terms of scale and allowed for 'the same amount of deception as a painting'. Despite this sense of modernity and innovation, Khan's work is in many ways a reflection on past history. Compressing time into single snapshots, he creates images that invite reflection on the original works of art or literature that are being referenced. Instead of being frozen in time, however, they resonate not only with their own meaning but as part of Khan's composite. The sense of vibration that emanates from the layered images gives each photograph a pulse, almost like a living being.

Khan confesses that he originally turned to photography because he 'could not paint', but feels that he has a strange relationship with the medium. 'I do not see myself purely as a photographer', he says, adding: 'I cannot remember the last straight photograph I took – I am always battling against the surface or thinking how I can push the medium to resemble a drawing or painting.' He cites painters and sculptors such as Agnes Martin, Frank Stella, Richard Serra and Anselm Kiefer as his chief influences, while also acknowledging inspiration from photographers such as Lee

Friedlander, Hiroshi Sugimoto, Eadweard Muybridge, William Henry Fox Talbot and Andreas Gursky. These influences figure regularly in his work: his 2010 photograph *The Creation* – a large abstract piece using the entire score of Haydn's music – refers to an Agnes Martin painting called *With My Back to the World*.

Khan is aware of the photographic practice that helps to succeed in the market place, keeping his edition sizes small (usually limited to six) and ensuring that the best materials are used: 'I choose the best printing technique, which is archival, and I always mount on aluminium so that the photograph stays completely flat,' he explains. Framing the finished works behind UV-filtered glass further improves their longevity. However, Khan believes that 'photography collectors fall in love with the image and not just the technique or material used', and his work demands attention and thought from the audience in the act of looking at it.

In addition to his photographic work, Khan works on sculpture commissions. Among his most recent projects is a contribution to the fourth instalment of the international exhibition *Lustwarande* in the Netherlands, and another for an arts organization called Locus+ based in Newcastle, UK. Khan's work has been exhibited internationally for several years, including shows in Finland and Switzerland.

edgar martins

born: 1977, évora, portugal

Edgar Martins came to photography having originally set out to be an author. After studying philosophy, his intention was to write and in 1996, aged eighteen, he published his first book. He describes it as an 'experimental bio-poetic-philosophical-novel' but looking back now, he views it mainly as an attempt to communicate with a larger audience and to make sense of the world around him. 'It was this book,' he says, 'that made me realize I needed to study visual imagery.' While his interest in photography at the time was not defined, he recalls being attracted to 'what I perceived to be the possibilities that the medium opened up'. What drives Martins now, he says, is not the possibilities of photography but in fact what he sees as the inadequacies of the medium; specifically, he is interested in its shortcomings as a means of communicating ideas. Martins claims that this spurs him on 'to find a new visual language to work with and a new vocabulary from which to derive "my glossary of life".'

Martins has gained international recognition for his photographic work, in particular the series *The Accidental Theorist* (2006–8) and *When Light Casts No Shadow* (2008). The former – a series of night scenes shot largely on the same set of Portuguese beaches – highlights the artist's interest in performance and the theatrical. The images take on the appearance of abandoned stages, resembling location shots for an imagined series of unmade films. The

untitled (the accidental theorist), 2008

untitled (the diminishing present), 2007

beaches are littered with unexpected objects – umbrellas and tyre tracks among them – that are almost entirely photographed as they were found. These are images of stillness and silence, conveying a sense of uncertainty and melancholy. *When Light Casts No Shadow* addresses a different kind of contemporary landscape. Produced on completion of a commission undertaken for the European Airports Authority, much of the series was shot in the Azores, where airports were used for stopovers on early transatlantic flights and served as important bases in the Second World War. Martins was drawn to their dilapidated appearance, shooting almost exclusively at night and using long

exposures of up to two hours to register the minute tonal differences he desired.

Borrowing from older art forms such as painting, Martins seeks to create 'a simple but layered language, which is universally accessible but draws on a multitude of subjects'. He relies on the inherent ability of photography to make the image believable, using the camera's reputation as a tool that 'records reality'. He then seeks to turn around this preconception by incorporating 'a disturbing suggestion that all is not what it seems'. The moment of recognition that follows, when the viewers become aware of their previously suspended disbelief, is vital. 'This process of slow revelation

old street (a metaphysical survey of british dwellings), 2010

and sense of temporal manipulation is crucial to my work,' he says. It makes the viewers acutely aware of the process of looking. Martins's well-crafted prints, centred on the attempt to express how difficult it is to communicate, are described by Martins himself as 'visually precise images that elude precise meaning'.

In addition to this personal work, Martins enjoys the challenge of commissions. The need to respond to the brief, to new situations and locations requires a different methodology. He welcomes these projects, embracing the shorter gestation period that contrasts so strongly with his usual time frame. He does, however, ensure that commissions remain artistically

oriented and ideologically driven, giving him a positive challenge.

When talking about the future of photography, Martins stresses the importance of having more organizations, institutions and individuals 'inciting artists to look beyond traditional forms towards innovative ways of using photography and extending its vocabulary'. Rather than the continual celebration of 'fashionable aesthetics', he wants to see more work 'with a strong thematic basis', supported by editors, curators and art directors. Similarly, he would like to encourage collectors to 'be brave enough to invest in artists early on in their career'.

richard misrach

born: 1949, los angeles, usa

OPPOSITE TOP
**bomb crater and
destroyed convoy, bravo
20 bombing range, 1986**

OPPOSITE BOTTOM
dead animals #1, 1987

Richard Misrach came to photography while studying at the University of California, Berkeley, in the late 1960s, when he saw the work of the photographer Roger Minick displayed in a gallery on campus. Looking at these photographs proved a life-changing moment for him: 'I knew immediately that this was what I was supposed to be doing,' he says. 'I had never felt that before or since.' So began a career that spans forty years and has seen Misrach recognized as one of the foremost photographers of his generation. He was a pioneer of the use of colour in contemporary photography and large-scale presentation, practices now widely used by photographers.

Misrach's themes are the landscape and the effect human intervention has on it. Seeking inspiration in nature and literature, he finds some of his strongest influences and inspirations in other photography. 'There is so much photography that I love,' he says, 'It is probably why I am a photographer, after all.' His understanding of the history of the subject and his love of the medium are profound: 'Has there ever been a more potent, aesthetic, cultural, economic or political medium?' He champions the ability of photography to transcribe the world on paper, calling it 'magic, pure and simple'. Misrach lists among his favourites early photographs of the American Civil War and the American West, as well as the work of Edward Weston, Walker Evans, Stephen Shore, Lee Friedlander and Thomas Ruff.

Misrach is perhaps best known for his *Desert Canto* series, an ongoing project begun in 1979, in which he focuses on the American desert, exploring the landscape's complexity and its

social, political and economic context. In what has become one of the most extensive projects in contemporary photography, Misrach produces images of startling beauty, detail and layered meaning. While he finds it hard to select a favourite among his work – 'That's like choosing one's favourite child' – Misrach concedes that it is the *Desert Canto* project that 'has given me the vehicle to address numerous subjects with multiple strategies, allowing me to create a complex, multifaceted exploration of landscape and culture'.

For the most part, Misrach has followed his instinct and his heart. Although he has taken on a few commissions during his career to allow him to continue with his own projects, he is in fact wary of commissions. Hard work and passion are what he believes make a photographer. He would advise any young photographers: 'If you are worried about career or the marketplace, find another line of work.' Similarly, he suggests collectors of photography should go only 'where their hearts lead them', advising them to explore and support young talent, rather than just buy what is advised or expected. He believes a good knowledge of the history of photography is also crucial for building a serious collection.

Misrach's other projects include the documentation of the industrial corridor along the Mississippi River called 'Cancer Alley', and a series of photographs of the Golden Gate Bridge in San Francisco, which he describes as 'a rigorous study of weather and time'. *On the Beach*, his latest project, sees him exploring issues of human interaction and isolation. This series marks a significant break from his work

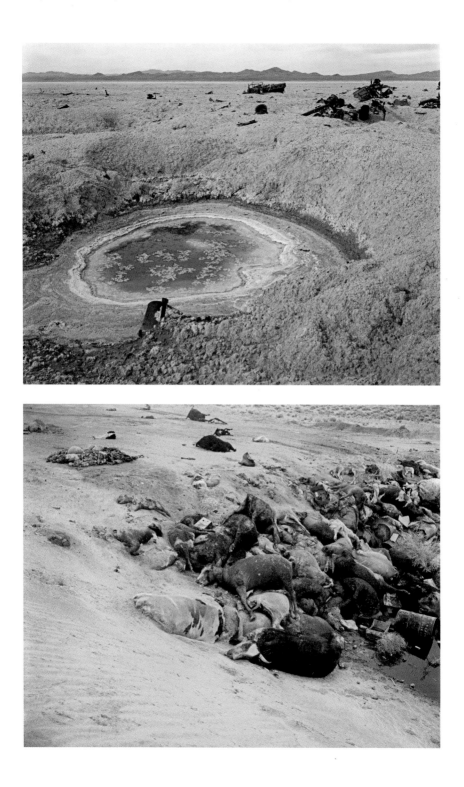

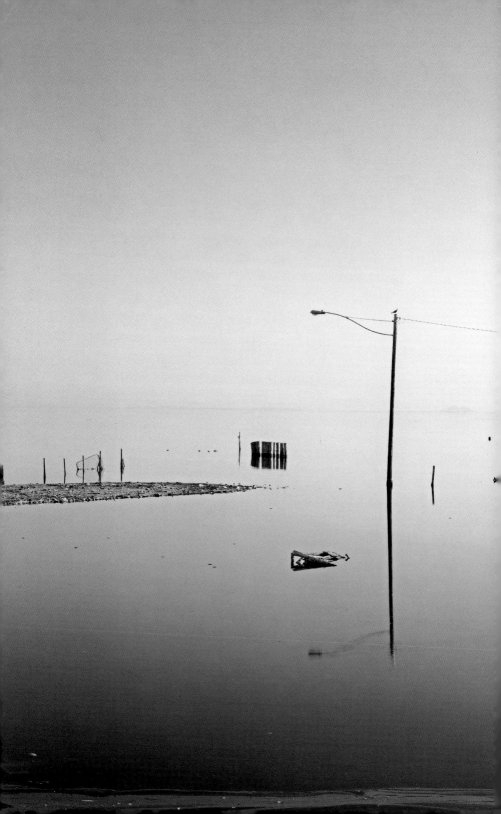

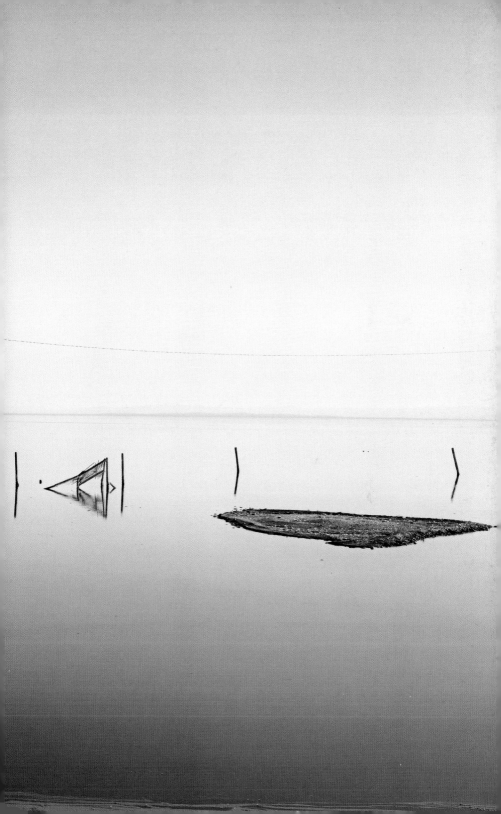

PREVIOUS PAGES
submerged lamppost, salton sea, 1983

BELOW
untitled, 2008

to date in that the images are his first created not on film but with a digital camera, yielding extraordinary detail. Misrach sees the digital revolution as a positive and significant transformation in photography. Instead of sending out his negatives to commercial labs for printing, he now makes all his prints himself, some as large as 3 × 4 metres (9 × 13 ft). 'The accessibility and ease of working like this, along with processing tools such as Photoshop, encourage play and experimentation,' he says. 'This will be the norm for the next generation of photographers coming out of school and it will represent a sea change in terms of what the medium is capable of achieving. Photography will never be the same.'

Misrach's work has been widely exhibited, and he has received numerous awards including four National Endowment for the Arts Fellowships and a Guggenheim Fellowship. In 2002, he received a Lifetime Achievement Award from the German Photographic Association, and in 2008 the Lucie Award for Outstanding Achievement in Fine Art Photography. Prints of his images are held in more than fifty public collections, including the Metropolitan Museum of Art and the Museum of Modern Art in New York, the Centre Pompidou in Paris, the National Gallery of Art in Washington, D.C., and the Tokyo Metropolitan Museum of Art, as well as in countless private collections worldwide.

untitled, 2007

where my grandfather drank #1, 2002

stephen j. morgan

born: 1970, birmingham, uk

Stephen J. Morgan's photographs are characterized by a sense of quiet and melancholy. Working largely around the area of his home town of Birmingham, Morgan has spent the last decade exploring the theme of memory, discovering his own relationship with it and its relation to photography. He describes two distinct ways in which he approaches his work: the first being photographing what he knows; the second, looking beyond his immediate surroundings to find 'the extraordinary in the everyday'. He explains, 'With the first I attempt to bring fragments of my life to my attention, and with the second I hope to bring fragments of the everyday to the attention of the viewer.' In both cases the focus and driving force come from himself.

Having struggled with learning difficulties as a child, Morgan was drawn to art at school and in this way determined his future course early on: 'I was always going down that path,' he says. Lacking the confidence to launch himself as a painter, he turned to the camera, it seems without much thought. But the experience was significant: 'I remember getting my first contact sheet and being amazed by it; I saw something magical that I still see today.' He believes the importance of photography lies in its accessibility, a quality that sets it apart from many other art forms. 'We read the message more clearly because photographs are part of our everyday lives – they jog our memory and sometimes they *are* our memory,' he says.

OPPOSITE TOP
ladywood fenian #15, 2008

OPPOSITE BOTTOM
**too many saviours for
my cross #3, 2003**

Working largely in series, Morgan begins
with 'a basic idea or thought' but then allows
his projects to develop freely from there. In the
series *Ladywood Fenian* (opposite top), for
example, he returned to the places of his
childhood in Ladywood in Birmingham, and
'walked where I used to walk and photographed
what I came across'. The resulting images range
from delicate close-ups of flowers, objects on the
ground and graffiti on walls to sweeping shots of
the towering apartment blocks that overshadow
the area. As part of another series, *I was born
an English Catholic*, Morgan again returned to
the scenes of his formative years, visiting the
Ladywood social club his grandfather frequented
(page 136). The five images taken here serve as
a poignant memorial to his grandfather. The
empty rooms are plain and unassuming, allowing
the viewer to imagine the laughter, music and
rowdiness that would have filled the place in
earlier times.

Alongside personal work such as this,
Morgan has worked on two very different
commissions for Birmingham National Library.
The first, in 2006, was a joint commission with
his father to photograph the four central points
of the community of Birmingham as part of the
restoration of the Town Hall. The featured
buildings also included the Symphony Hall, the
Ladywood Social Club – the location of the
abovementioned series *Where My Grandfather
Drank/Where My Grandfather Sang* and the
Lee Bank Community Centre, which was due
for demolition the day after Morgan shot there.
Entitled *Four Stages of People*, the project had
a clear public purpose, with the concept outlined
by the curator of the library. The second
commission was to form part of the National
Library's 2007 *Station* exhibition. Less didactic
in nature, it grew out of an idea Morgan had to
do a series of portraits of train spotters, and the
library's suggestion to show images from the
archive of Birmingham's history of rail. The
resulting compromise was the series *SVR*, a
project on the Severn Valley Railway in nearby
Shropshire, which captured both the railway
and the people who rode it.

While still developing a profile in the
commercial gallery sector, Morgan is very aware
of the collecting market and tailors the production
of his prints to suit. 'All my works come in
editions of six,' he says. 'One of these is for me,
meaning there will only ever be five prints out
there.' His photographs are printed in London,
in two sizes because 'I realize not everyone
wants a big photograph on their wall'. Working
largely with digital C-type prints, which allow
his self-financed projects to be completed on
budget, Morgan nonetheless laments the decline
in traditional printing techniques that has
followed developments in digital technology.
'When I started out, photography was taught
as a craft; in the digital age it is often difficult to
see it like that.' As a nod to the C-type, Morgan
always has a traditional print done and matches
the digital ones to this, aiming for the highest
possible quality in the presentation of his
images. 'And they do match,' he says. 'The
quality is amazing, but I do miss the darkroom.'

youssef nabil

born: 1972, cairo, egypt

Growing up in Cairo, Youssef Nabil was captivated by cinema from an early age. He watched old Egyptian and Hollywood films, enthralled by the story lines, the elaborate sets and costumes and the glamour of the stars. He describes with a real sense of shock and sadness the moment when he became aware that many of these actors were no longer alive. From this realization arose a desire to meet those who were still living and immortalize them in his imagery. The first step was taken in the early

1990s when Nabil asked his friends to sit as models, staging scenes in which everything was styled to perfection – the lighting, hair, make-up and setting. Initially using only black-and-white images, Nabil decided to move to colour but rejected colour film, believing that it did not give the right feeling to his work. Instead he chose to continue with black-and-white photographic prints and colour them in by hand. He adopts this technique for all his work, and in the process removes blemishes and other marks

OPPOSITE
catherine deneuve, paris, 2010

BELOW
sweet temptation, cairo, 1993

of reality, recalling the aesthetic of the glory days of Egyptian film.

From the mid- to late 1990s Nabil worked as an assistant to both David LaChapelle in New York and Mario Testino in Paris. Now based primarily in New York, Nabil often returns to Paris to print his photographs, maintaining a strong relationship with his lab there. Crucially, his work requires his prints to be made in the darkroom, as the addition of the watercolour, oil and pastel with which he colours the images necessitates the use of fibre-based, rather than digital, photographic paper.

During his time as an assistant Nabil photographed artists and friends, and perfected his artistic technique on his return to Egypt in 1999, capturing the writing, singing and acting stars of the Arab world. Subjects have included fellow artists Shirin Neshat, Mona Hatoum and Marina Abramovic, as well as Gilbert and George, Catherine Deneuve (opposite), Zaha Hadid, David Lynch, Omar Sharif and Tracey Emin. Nabil produces formal portraits of his sitters but has also created a series of portraits depicting his subjects asleep, removing them from the comfort of their usual setting and capturing them away from their public personas. Sleep is a recurrent theme in Nabil's work. Often linked to death and sex, Nabil also believes it is connected with travel: 'I don't think we just go to sleep and that's it. I think we travel, go somewhere. I think when we die it's going to be more or less like this. We'll be here, but we'll be somewhere else.'

Nabil's own travels have also influenced his work. Attending a French school in Cairo gave him an interest in other cultures, which he

values highly. When he lived in Europe, removed from the country of his birth, Nabil began to create a series of self-portraits, capturing himself as a visitor in different locations including Florence, Vincennes, Paris, Sardinia and Naples. In these shots Nabil is often not looking at the camera. In this way he leaves the images open to interpretation: the person depicted could be anyone, which allows the viewers to project their own views on to the scene. Nabil acknowledges that a sense of melancholy pervades these images, and that they form part of a commentary

on life in general, and his own life more specifically. In particular, Nabil's thoughts about the departing of life are mirrored in his arriving in and departing from each of these different cities. The personal element in Nabil's work is evident. 'Each project is important to me because it represents a different time in my life,' he says. Wherever he is based in the world, Nabil maintains a connection to his homeland: 'I am always dealing with issues that relate to my culture, my own experience and where I come from.'

Coming full circle to the medium that inspired and influenced him in his youth, Nabil has recently completed his first film, an eight-minute piece entitled *You Never Left* with Fanny Ardant and Tahar Rahim. His photographic work has been shown in numerous solo and group exhibitions since his first exhibition in Cairo in 1999, in venues as diverse as the British Museum in London, the Centro de la Imagen in Mexico City, BALTIC Centre for Contemporary Art in Newcastle, the Michael Stevenson Gallery in Cape Town, the Institut du monde arabe in Paris, the Kunstmuseum in Bonn, the Villa Medici in Rome, and the Aperture Foundation in New York.

self-portrait with botticelli, florence, 2009

simon norfolk

born: 1963, lagos, nigeria

Having harboured a desire to pursue a career in academia, it was during his studies in philosophy and sociology at Oxford and Bristol universities respectively, that Simon Norfolk was introduced to photography. A tutor showed him two books that combined sociology with photography: *Fighting the Famine* by Mike Goldwater and Nigel Twose, and *Working for Ford* by John Hedges and Huw Beynon. In studying these, Norfolk discovered that the medium of photography could present ideas he had hitherto assumed could be expressed only in words. So he changed direction, taking a documentary photography course in Newport, South Wales, after which he worked for a number of magazines, on projects photographing far-right and fascist groups. Subsequently, his documentary work took him further afield: to Israel, Palestine, Bosnia, Iraq and Afghanistan, and many other places.

In 1994, Norfolk gave up photojournalism in favour of landscape photography. As he recounts: 'I went to Auschwitz as part of a story and took with me an additional square format camera. The shots I came back with were static, quiet, inarticulate even, but that seemed entirely appropriate for such a subject, whereas the photojournalistic pictures I had taken seemed aggressive and needlessly loud. That was a Damascene moment for me.' While he still produces commissions for publications such as the *Guardian* and the *New York Times*, they do need to fit with his own objectives for his photography: 'I have an editor at the *New York Times Magazine* and the only brief she supplies is "Give me something I have not seen before." For me this is the best assignment – it is exactly the kind of thing I should be doing anyway.'

Norfolk's work recalls earlier periods in the history of photography, namely the documentary tradition and early photojournalistic images from the decades after the medium's invention. He acknowledges that his images also follow a trend in European art, apparent since the Renaissance, of 'a fondness for ruin and desolation that has no parallel in other cultures'. Within contemporary photographic practice, Norfolk's landscape imagery is refreshing, set apart from the fashion for portraiture and self-portraiture so prevalent among many photographers in recent decades.

Norfolk's images exude a subtle eloquence and calm, which conversely provoke a rush of

auschwitz: staircase in a prison block, 1996

OPPOSITE
**glory trip 197: an unarmed
minuteman lll missile is launched
from vandenberg air force base,
california, 2008**

OPPOSITE TOP
**former teahouse next to the
afghan exhibition of economic
achievements, kabul, 2001**

OPPOSITE BOTTOM
**the 'marenostrum' supercomputer
in a disused church on barcelona
university campus, 2005**

words and descriptions. By approaching his subject through direct interaction he reinforces the immediacy of photography and underlines the accessibility of the medium. Coming from a photojournalism background, he draws attention to the relationship between photography and text and how the latter can influence our reading of images. With his editorial work, the images are often accompanied by words supplied by others, while in the gallery environment Norfolk himself incorporates language as part of the whole concept. Here, the caption or explanatory text does not have to compete with the image and 'the meaning is entirely my own'. His own publications are littered with quotations and references; but, as the title of his 1998 publication, *For Most Of It I Have No Words: Genocide, Landscape, Memory* emphasizes, his pictures can speak volumes without language.

Norfolk has spoken about occupying a 'half-space, somewhere between art and documentary photography'. In some ways his work is at the centre of a debate that has raged since the 19th century: whether photography is used simply to record scenes and objects or can be said to have artistic attributes. Norfolk demonstrates that the two aspects can co-exist. His images are exhibited and collected as artworks: he is represented by commercial galleries in London, New York and Los Angeles, and his work appears in major public and private collections worldwide, including the J. Paul Getty Museum in Los Angeles and the British Council Collection. More often than not, the motivation behind the work comes from a photojournalistic instinct to document and a desire to show the world something crucial about its past and present. Norfolk remains passionately attached to the purpose of his work, eschewing the trappings of being an 'artist'. He is not interested in fame or publicity, although he has received numerous awards, such as Le Prix Dialogue at Les Rencontres d'Arles in 2005 and the European Publishers Award for Photography in 2002 for his coverage of the war in Afghanistan in his book *Afghanistan: Chronotopia*. Instead he talks of the importance of a real 'persistence' and 'traction' in photographs. It is this, he believes, that encourages people to look for the ideas behind his work; and it is the constant development of these discussions that gives artworks their longevity. For Norfolk, the collectors of his work are guardians, not simply of the physical prints but of his ideas.

martin parr

born: 1952, epsom, uk

Martin Parr is a celebrated photographic
chronicler of society. A full member of Magnum
since 1994, he produces work with the
documentary focus that characterizes the
agency's vision but also brings a unique
perspective to his imagery that sets him
apart. He studied photography at Manchester
Polytechnic from 1970 to 1972 but was
introduced to the medium some time before,
as a teenager visiting his grandfather in
Bradford. 'My grandfather was a keen amateur
photographer and at about age thirteen or
fourteen he converted me. We went out
shooting, processed film and made prints.
I knew then I wanted to be a photographer,'
he explains. At Manchester, Parr found the
structure of the course limiting, as it was
concentrated on basic studio technique with
a view to students working as photographers'
assistants. He began to work on projects of
his own and has not looked back since.

Travelling the world, Parr has sought out the
concepts that fascinate him the most – leisure,
consumption and communication – in countries
including Japan, India, China and the United
States. Turning his lens on his home country,
Parr documents with humour, compassion and
slight mockery the eccentricities of the British
people and their lives. He does not ask for
permission from his subjects to take a
photograph; rather he has become an expert in
reading body language, sensing when and
where a photograph can be taken and what will
make it work. It is often a case of waiting for the
different elements of a composition to fall into
place in front of him – 'most of the pictures are
ad lib,' he says. In recent years, Parr has begun

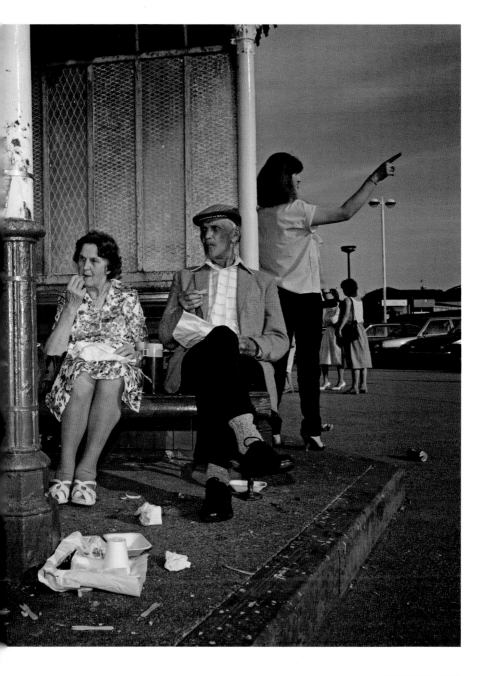

new brighton, 1985

benidorm, 1997

to increase the number of close-up photographs he produces, putting details of people, food and other objects in focus so individuals are less recognizable.

Colour is a key element in Parr's work. He started to focus on it in the early 1980s, finding inspiration in the imagery of American photographers such as Joel Meyerowitz, William Eggleston and Stephen Shore. Parr's signature style is bright, saturated colour: he uses amateur film, which, combined with the flash, produces the desired effect. He does not use Photoshop or otherwise manipulate his images. This practice is now essential to his work, and it has become utterly natural to him: 'It is something I do without even thinking about it. I have not shot in black and white since 1986.' In recent years he has welcomed the introduction of

digital photography, which he began to use in 2006. 'It means more things are possible and, through the internet, we are getting bigger audiences for our work,' he says; yet he believes that these new developments have not materially affected his working process. 'It just means that, with digital, especially in low light, you have more flexibility. And you don't run out of film.'

Parr began to produce fashion imagery towards the end of the 1990s when the Italian magazine *Amica* first commissioned work from him. He now does approximately five fashion shoots a year and says that he approaches this kind of work in much the same way as he does his personal projects: 'When I am shooting for myself I obviously have to arrange things more, as it is part of a bigger agenda. But I am happy to go anywhere and take photographs.' Commissioned work, advertising assignments and editorials such as portraits for *The Times* comprise approximately half of Parr's output. He does not differentiate between the different sides of his work or categorize his imagery, however. 'The interface between different genres is slipping away,' he says. 'They all blur into each other these days. Art can be fashion and documentary work can be in art galleries.'

A prolific producer of artists' books, Parr published his first in 1982 and has since gone on to create more than fifty, in addition to acting as editor for many publications of other artists'

work. He prefers not to comment in written form on his own work, however, saying: 'I want the photographs to do the talking'. As a strong influence he mentions Japanese photographer Nobuyoshi Araki, whose publishing output impresses him, and he talks with enthusiasm of the history of photography book design and publishing in Japan, a country he has returned to almost every year since his first visit in 1990. Parr has also co-edited a significant two-volume work entitled *The Photobook: A History*. With this publication, Parr – a collector of photobooks himself – has helped to situate the subject within the fields of both photography and publishing, establishing the photobook as a collecting category in its own right.

Parr is a regular guest curator, with recent curatorial stints at the New York Photo Festival and the Brighton Photo Biennial. Since 2004 he has been Professor of Photography at the University of Wales. Prints of his images are held in public collections across the world, including the Arts Council of Great Britain, the Victoria and Albert Museum in London, the Bibliothèque nationale de France in Paris, the Museum of Modern Art in New York and the Museum of Modern Art in Tokyo. Television and film credits include a video for the Pet Shop Boys in 2002, the short film *The World of Martin Parr* for the BBC in 2003 and, more recently, the 2010 documentary *Art of the Sea*, examining the response of British artists to the sea.

emily (polyester), 2007

alex prager

born: 1979, los angeles, usa

Alex Prager is one of the newest stars of the contemporary photography scene in the United States. With her career still in the ascendant, she has already secured key gallery representation in London, New York and her home city of Los Angeles, and her work is being acquired by international institutions. Prager's somewhat unconventional formative years, which saw her split her time between Florida, California and Switzerland, left little room for formal education. While interested in art in her teens, she did not go to art school and found her way to photography by pure accident – a chance encounter had a great impact on her: 'I stumbled upon a William Eggleston exhibition at the Getty Museum in 2000,' she explains. 'From that moment it was only about a week until I had bought a professional camera and set up a fully operating darkroom in my bathroom. It was instant for me.' She is currently working between New York and Los Angeles, the latter location influencing her work to date as the place of her childhood. Her use of colour, which echoes that of Eggleston, recalls the aesthetic of the 1960s and 1970s – decades that have shaped the architecture and environment of that particular part of West Coast America.

Prager has produced three major series to date: *Polyester* (2007), *The Big Valley* (2008) and *Week-End* (2010). Alongside Eggleston, she cites photographers such as Weegee, Diane Arbus, Guy Bourdin, Helmut Newton, Joel Sternfeld and Philip-Lorca diCorcia (pages 68–71) as influences, and aspects of each of these artists'

work can be traced in her imagery. Often
working with a team of stylists and make-up
artists, Prager creates dramatic, staged tableaux
that she describes as 'mood pieces' rather than
narrative dramas. Cinematic in scope and often
melodramatic in theme, her work has been
likened to that of Cindy Sherman and Alfred
Hitchcock. In particular her first series, *Polyester*,
has often been linked to Hitchcock's work, and
Prager – partly in homage, partly in the hope
it would bring comparisons to a close –
subsequently created an image with birds as
a reference to Hitchcock's famous film.

The concept and emotion of the image
seems to be the main emphasis for the
photographer, and her methodology is personal
and immediate. 'I have a very general idea
before I start,' she says. 'Then I close my eyes,
shoot like a madman and hope it all looks good
in the end.' This casual-sounding approach

belies Prager's attention to detail and effort to
find the right technology for her imagery. Her
fascination with colour leads her to deplore the
demise of the dye-transfer process, which
produces prints of high colour saturation, but
also more generally the advance of digital
processes. 'I am a little disappointed in all the
photographers who dropped film and picked
up digital cameras so quickly,' she says. 'I
think there is no question that film still produces
better-quality photographs when looked at on
a larger scale.' Needless to say, Prager spends
a great amount of time in post-production,
ensuring that the colours of her images turn
out the way she desires, and in that context
she appreciates technological advances.

While accepting editorial commissions on
a regular basis for publications including *New
York Magazine*, the *New York Times Magazine*,
Dazed & Confused, *Tank* and *i-D*, Prager stands

OPPOSITE
eve (big valley), 2008

RIGHT
**alexandra
(polyester), 2007**

BELOW
**nancy
(big valley), 2008**

firm in the belief that such projects should not interfere with her approach or the audience's reception of her work. 'If the pictures are great, who cares who or what they were made for?' she asks. 'I am not interested in whether or not they were commissioned by a company or how widely they are seen. The only thing that should be important is how good the end result is. Some of the greatest works of art were done on commission.' With her refreshing attitude and adaptable style, Prager has turned her hand to a variety of projects. In 2010 she completed two short films, *Sunday* and *Despair*, undertaken in order to break through a 'wall' she felt she had hit with photography, having completed three series in a consistent style. The desire to challenge herself and change her approach led her to take up the project. It will be interesting to see what she tries next.

the glory of hope, 2007

wang quingsong

born: 1966, heilongjiang, china

Since the beginning of the 21st century Western interest in contemporary Chinese art has increased and catapulted several artists into the limelight, seemingly out of nowhere. In truth, these contemporary artists have been producing noteworthy works for many years. While the dip in the art market in late 2008, connected to wider economic concerns, had repercussions for many of his contemporaries, Qingsong saw his innovative artworks attain an important place in modern photographic history.

Today, Qingsong works with various media including photography, video and sculpture, but until 1996 he had concentrated on painting, having studied oil painting at the Sichuan Fine Arts Institute. He recalls finding his 'niche' in photography after moving to Beijing in 1993, at a time when the country was experiencing 'drastic changes', and there was a nationwide 'pursuit of commercial success'. Qingsong realized that it was photography – a medium he describes as 'intimate, realistic, affectionate, illusory' – that could best communicate his feelings about the changes he saw happening on a daily basis.

Qingsong's images reveal a fascination with humankind: in particular, people's ability to adapt and develop in changing circumstances, and the ability of different cultures to influence each other and change in the process. He is intrigued by the history of colonialism and indigenous populations, for example, and believes that analysing these can shed light on 'how global society can address issues of common concern with understanding and respect'. As a citizen of a country with a vast population (1.3 billion and counting), Quingsong

tries to understand what all these people are thinking and doing, and what they dream of for their future, which he describes as a great motivation for his work. *The Glory of Hope* (opposite), was produced in large format – approximately 240 × 180 cm/94 × 71 in. – to match the scale of China's expectations and efforts as it prepared to present itself to the world in the 2008 Olympic Games.

One of Qingsong's best-known images is, perhaps unsurprisingly, the one of which he says he is most proud: *Follow Me* (see pages 10–11) is a self-portrait of the artist at a schoolteacher's desk, with a vast blackboard behind him that is covered in Chinese and English scrawlings, including corporate logos for Nike and McDonald's. Qingsong sees the work as 'a summary of all our childhood experiences', yet on closer inspection, one reads in it further messages to the world: 'Let China walks [sic] towards the world! Let the world learns [sic] about China!' and 'Great Olympics' are phrases that leap out from the seemingly unordered patterns on the board. Once again huge in scale (prints have been made in an impressive 120 × 300 cm/47 × 118 in. format), the intricacy of the picture fascinated audiences when it first appeared on the market.

Alongside personal projects such as this, Qingsong has completed commissions for various prestigious companies. In 2006, he was invited by Selfridges department store in London to create a nineteen-window display celebrating Chinese New Year, and in 2008, Christian Dior celebrated the brand's sixtieth anniversary by launching a project with twenty Chinese artists, of which Qingsong was one. For the latter he

BELOW
temporary ward, 2008

BOTTOM
night revels of lao li, 2000

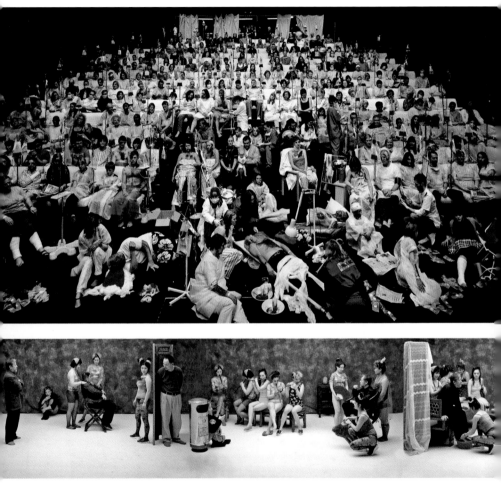

created his work *Nutrients*, an intriguing
composition reminiscent of the Last Supper,
showing models dressed in couture, surrounded
by empty beakers and hospital equipment –
a comment on Qingsong's own negative
experiences of hospitals. Also in 2008, the
experimental theatre Northern Stage in
Newcastle, UK, invited him to collaborate with
three hundred volunteers for their cultural
programme 'East and West'. The result was
the photograph *Temporary Ward* (opposite):
the three hundred subjects are presented in
the theatre's auditorium dressed as patients
and medical staff, as Qingsong establishes a
connection between the theatre's capacity for
facilitating psychological well-being and the
role of hospitals in ensuring, or failing to ensure,
physical well-being.

The level of detail in Qingsong's images
makes a great impression on the viewer. Rarely
working in series, the artist instead conceives
of one large, self-contained image after another.
While he may therefore offer his audience a
smaller number of images in total, he seeks to
create photographs that entail 'a lot of
discoveries'. Before taking the final photograph
he will often collect material as a way of creating
a visual 'archive' for himself; in the final result,
however, his aim is to minimize the information
so that he can express the bigger message
as succinctly as possible. Qingsong stresses
the importance of studying the history of
photography to better understand why an artist
has made certain visual choices. It is his passion
that drives him, and he wishes to inspire a
similar desire in his audience.

ed ruscha

born: 1937, omaha, usa

Pasadena Art Museum in California, one of the first Pop Art shows in the United States.

Raised in Oklahoma City, Ed Ruscha left his home town after graduating from high school in 1956 and headed for Los Angeles, where he studied at the Chouinard Art Institute (now the California Institute of the Arts). Taking fine-art classes alongside his graphic design course, Ruscha quickly established that the Abstract Expressionism that dominated the teaching went against his own artistic instincts. Working at Plantin Press during his course, he discovered an interest in book production and learned to set type by hand, and a stint at an advertising agency taught him layout and paste-up skills. At the same time the desire to create work of his own was growing. He began to work in a preconceived manner, envisaging the composition of his paintings in advance, the tensions between foreground and background, and incorporating words and typefaces as he started to employ everyday language and imagery from his surroundings in his pieces. Since that time Ruscha has consistently used the cityscape of his adopted home town of Los Angeles, together with vernacular language, to explore the urban experience and create an incisive portrait of American culture.

Ed Ruscha is celebrated internationally for his achievements in the fields of painting, photography, printmaking, artists' books, drawing and film. His work is connected to the Pop Art movement that emerged in the late 1950s in the United States; it was characterized by themes and techniques drawn from popular culture such as advertising imagery and comic books, and it challenged people's views with the assertion that the artist's use of mass-produced visual commodities had a place in fine-art tradition. In 1962, pieces by Ruscha were included alongside works by Andy Warhol, Roy Lichtenstein, Jim Dine and Wayne Thiebaud in a groundbreaking exhibition entitled *New Painting of Common Objects* at the

Ruscha's work is consistently innovative, but he always returns to the overarching theme of words and their shifting relationship with context and message. He is driven by this fascination with language – its power and its enigmatic quality, its capacity for ambiguity and paradox. His interest lies in the banality of urban life and the avalanche of information

swollen eye, 1973

OPPOSITE
st tropez, apartment building, 1965

with which we are assaulted on a daily basis
by the mass media. Ruscha describes his first
contact with photography as having been
through images in magazines, and confesses
that at first 'photography was for reproduction,
at least for me'. Naturally, his early work within
the advertising industry influenced and
strengthened these ideas, but Ruscha revised
his opinions when he saw the work of Walker
Evans, Man Ray and Robert Frank. The Pop
Art movement was strongly associated with
the artist's use of mechanical means of
reproducing images or rendering techniques.
Thus photography, and the making of
photobooks, was a natural progression for
Ruscha's artistic output. Today he sees fine
arts and commercialism as 'running side by
side on the photographic stage' and lists Lewis
Baltz, Robert Adams, Stephen Shore, Thomas
Demand, Catherine Opie, William Eggleston,
Seydou Keita and Cindy Sherman among the
many photographers whose work he admires.

Ruscha claims that he does not have to
work hard for inspiration: 'It comes to me
unannounced – I never seem to look for it.'
Each of his projects takes on its own character,
and the procedure is never the same:
'Sometimes it is a matter of sweeping up
rejected things to give a work original value,'
he says. 'It is something I like to call "waste
retrieval"', a practice of taking things from the
past and resurrecting them. Ruscha's early
graphic design training continues to inform
his work, and artists' books, including several
photobooks, are an important part of his output.
In 1963, *Twentysix Gasoline Stations* was
published in a limited edition of four thousand

standard, amarillo, texas (gasoline stations), 1962

copies. Comprising twenty-six utilitarian black-and-white images of gas stations taken in 1962 along Route 66, the work is significant in its detached documentary style that presents the images as a catalogue of data. It not only refers back to the photography of Walker Evans and Robert Frank but also anticipates the work of Bernd and Hilla Becher, who have been very influential in the development of a new direction in contemporary photography. In 1966 he continued this theme with the publication of *Every Building on the Sunset Strip*, a photographic panorama of the part of Sunset Boulevard that runs between Hollywood and Beverly Hills. It was Ruscha's fourth book, and it departed from the format of its predecessors in its use of just one specific location photographed in its entirety. Described as the most physically ambitious of Ruscha's books, it comprises one long panoramic image, tipped together in nine sections and accordion-folded. Through this documentation of one place, registering all detail in black and white, Ruscha demonstrates an extraordinary ability to present the factual as an artistic statement.

Ruscha still lives and works in Los Angeles, carrying on his artistic development with no sign of let-up. His work has been shown in numerous museum retrospectives the world over. Since his first solo show in 1963, Ruscha has exhibited at the San Francisco Museum of Art, the Centre Pompidou in Paris, the Museo Nacional Centro de Arte Reina Sofia in Madrid, the Museum of Contemporary Art in Sydney and recently in a significant retrospective entitled *Fifty Years of Painting* at the Hayward Gallery in London. In 2002, a volume of Ruscha's

writings and interviews, *Leave Any Information at the Signal,* was published and a major *catalogue raisonné* of Ruscha's paintings is in progress, projected to extend to seven volumes covering his entire corpus from 1958 to the present.

With such a long-standing career and wide-ranging oeuvre to consider, Ruscha himself has the best advice to offer his audience; as he said in the introduction to his 2009 retrospective at the Hayward Gallery in London: 'There's just no right or wrong way to approach my work, and each viewer will come with his or her own associations anyway. And that's the way it should be.'

ross the rooster, 1960

alec soth

born: 1969, minneapolis, usa

American Alec Soth is a documentary photographer in the tradition of such great practitioners as Robert Adams, William Eggleston and Walker Evans. He was, by his own admission, 'born and raised on American photography', so it is perhaps unsurprising that his work recalls the period charted by these illustrious names. Soth confesses to being 'a failed painter' and acknowledges that it was this that brought him to photography in the first place: 'I did earthworks [works of art created in nature, using the landscape and materials found there] and documented these photographically. This led to photography,' he explains. Despite responding readily to the medium, he retains the view that 'the idea of engaging with space is more important than the actual making of photographs'.

This 'engaging with space' is evident in Soth's work, which has taken him all across America, exploring and documenting its landscape and culture. Describing his photographic style as 'flexible and organic', he says that the premeditated aspect of his work often vanishes once the project is under way: 'I start with some ideas, but the first trip into the field invariably changes everything.' Soth cites his book *Sleeping by the Mississippi* as his favourite project to date: it evolved from a number of road trips along the Mississippi River, where he photographed an eclectic mix of individuals, landscapes and interiors. Race, politics, art, crime, religion, sex and death – all are represented here, and more. The large-format colour prints of these images are rich in detail and evocative, combining a documentary element with a poetic approach:

'It will always hold a special place for me. I'll never be able to recreate the joy and naivety of that first book.' Two years later, in 2006, his second book *Niagara* was published, reproducing a series of images taken over the course of two years on both the American and Canadian sides of the Niagara Falls. Soth was drawn to the place 'for the same reason as the honeymooners and the suicide jumpers: the relentless thunder of the Falls just calls for big passion'. Producing images of intensity but quiet in mood, Soth invites the audience into the private world of his subjects.

The reproduction of his photographs in book form is important for Soth. In fact, he admits to being 'a much more avid collector of photography books than prints'. In stressing the importance of photography as an artistic medium, he says: 'I don't just limit this to prints on the wall.' The presence of his printed photographs in private and public collections is undeniably a source of pleasure and pride to him: 'It is a great honour to have people living with my work and an even bigger honour to have institutions caring for it.' But at the same time Soth claims that he tries to 'limit the influence of the market on the making of the work'; that is, he does not want to allow the collecting market to determine the projects he works on. 'I know that pictures of pretty young women sell. But,' he says almost triumphantly, 'the most recent project I did was on bearded middle-aged men.' He believes that passion and patience are key: 'It is incredibly easy to make photographs, but it is incredibly difficult to make great photographs. Since making pictures is easy, many photographers try to market them

home, treasure island casino, red wing, minnesota, 2002

**the reverend and
margaret's bedroom,
2004**

prematurely.' Passion is crucial for collectors
of the medium too, he believes. Beyond any
financial considerations, for Soth enthusiasm
for the subject should come first: 'Just as
making art should be more about passion
than business, collecting should be the same.
The best collectors are similar to artists. Their
collection is an expression of love and yearning.'

In 2008, Soth became a full member of
Magnum, the renowned photographic
co-operative, and worked on several cultural
commissions for them as well as occasional
portraits. He has contributed to various
publications including the *New York Times
Magazine* and *Newsweek* and also founded a
publishing house called Little Brown Mushroom
in 2010. His work is sold by galleries in Europe
and North America and held in major private
and public collections including the San
Francisco Museum of Modern Art, the Museum
of Fine Arts in Houston, the Minneapolis
Institute of Arts and the Walker Art Center,
also in Minneapolis.

thomas struth

born: 1954, geldern, germany

Thomas Struth is one of Germany's foremost contemporary artists, and since the 1980s his work has also gained recognition on an international scale. He trained at the Düsseldorf Academy of Art under Bernd and Hilla Becher: their photography course boasts an impressive list of famous alumni, including Andreas Gursky, Thomas Ruff, Candida Höfer and Axel Hütte. Struth, however, did not come to the Becher course, or indeed to photography, immediately. 'In the beginning I was a painter – at high school and as a kid I made drawings and paintings,' he explains. He enrolled in the academy in 1973 to study fine art and was taught by Peter Kleeman and Gerhard Richter. 'Sometimes they used photographs to develop paintings from and I began to think maybe I should do that – instead of using someone else's photographs I should make the photographs myself. Then at

a certain point I realized that this was a better fit for my impulses and character and what I am interested in.'

Having switched to the Bechers' course, Struth found himself drawn to what he describes as photography's connection to reality. 'With photography there's more of a shared experience with the public. It is more direct. Today people make things that look like photographs but are actually digitally invented. At the time – thirty-five years ago – this did not exist. I like the connection to the subject matter: it belongs to the real world.' This connection can be seen in Struth's early work, which comprises black-and-white studies of city scenes. Travelling to Japan, the United States and across Europe, he captured not only buildings and streets, but the atmosphere and the relationship people have with the city they live

53rd street at 8th avenue, new york/ midtown, 1978

pergamon museum 1, berlin, 2001

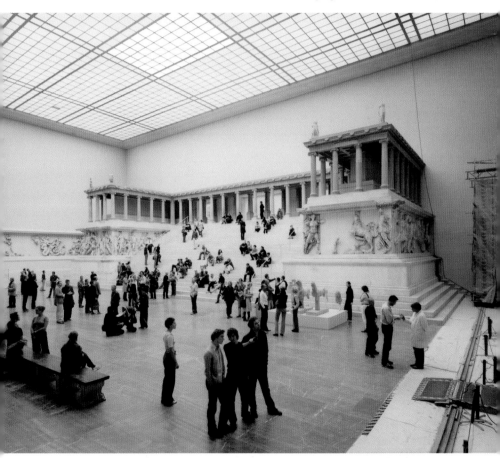

in. These images were collected in the 1987 publication *Unconscious Places*.

Struth has developed this theme of people's relationship with their environment throughout his major series to date. His *Museum* photographs, for example, look at the behaviour of people in a specific socio-cultural context. For this project, Struth travelled to some of the most celebrated art institutions in the world, including the Louvre in Paris, the Museo del Prado in Madrid and the Galleria dell'Accademia in Venice, to capture groups and individuals as they gazed at some of the world's most famous paintings. Group dynamics, individual behaviour, the conflict between how one 'should' behave in such a situation and how one actually does – all this is captured by Struth's lens. He sometimes worked with a tripod mounted on

wheels to allow easy movement around the galleries. Some visitors appear to have noticed his presence, but no doubt without understanding the purpose for which they were being observed. The resulting collection of images was first published in book form in 1993 but Struth has worked on the series on and off for many years. 'Photographing *Museum* took much longer than I initially thought,' he says. 'The first thirteen or fifteen pictures were made within two years. Then there was a fairly long break. And then about ten years later I picked it up again.' Struth's interests are sufficiently coherent to allow him to return to a series years later and for it to still be relevant to his body of work as a whole.

In the mid-1980s Struth began to produce family portraits, inspired by a psychoanalyst

friend's methods for finding out about his patients' backgrounds and driven by his own interest in the construction and identity of the family as a unit. In a break from his usual sphere of work – city streets or the vast halls of big institutions – Struth entered a smaller, domestic space and found it to be a wholly different experience. 'Working with families is always the most nerve-racking and intense because of the responsibility. They expose themselves to me but I expose myself to them as well because I am often as nervous as they are.' The relationships with the subjects were formed in a number of ways. Some families portrayed in the series have a close link to the photographer, coming from his own social circle, while others had been introduced through mutual friends or associates. Struth always found himself drawn to something particular about the family groups: 'I heard something about the family, maybe a narrative that interested me. It could be that the husband was my age or generation and that created a link. Or it could be that it was a Japanese family with five daughters in Hiroshima – something unusual that made me think "let me look at that".' In 2011 Struth was invited into a very different domestic space – a drawing room in Windsor Castle – to photograph Queen Elizabeth II and the Duke of Edinburgh. Commissioned by the National Portrait Gallery in London, the portrait shows the royal couple sitting side by side, captured in Struth's distinctive style, for the Queen's Diamond Jubilee in 2012.

Struth sees all his work connected by strong thematic links: 'It is almost like a big, complex building with different wings and different floors,' he explains. 'The entire thing is one big construction but sometimes I work on this wing for quite a long time, then a little bit there, and then I go back to this other thing. It's one building but all different chapters or different aspects of life.' His *Paradise* series, begun in 1998, at first glance appears to be a departure from his work to date, but Struth still ties it into his overarching ideas. The series comprises images taken in the jungles of Australia, Japan and China and in the woods of California. Printed in large format (up to 180 × 290cm / 71 × 114 in.), individual forms can be hard to make out within the detailed composition. Struth does not himself view them as depictions of nature, but describes them as 'unconscious places', linking to the ideas from which his early city pictures were conceived. Without a socio-cultural context – in contrast to the pictures of institutions there is no specific cultural or historical framework – Struth seeks to emphasize the self. The stillness and vastness of the subjects invite meditation and internal dialogue.

Struth's photographs have been the subject of worldwide exhibitions since the 1980s, and he was the first contemporary artist ever to be exhibited at the Museo del Prado in Madrid in 2007. Examples of his work can be found in international public and private institutions, and prints have appeared regularly on the auction market for many years.

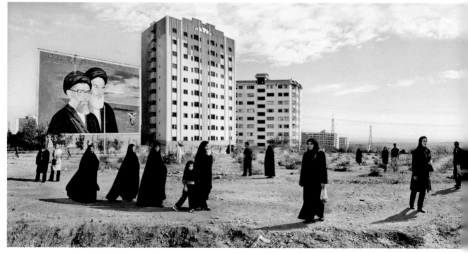

mitra tabrizian

born: 1964 tehran, iran

Photographer and filmmaker Mitra Tabrizian
was born in Iran and studied photography at
the Polytechnic of Central London (now the
University of Westminster), putting together
her first shows in the mid-1980s. The themes
of her work reflect those of her own life, covering
migration, exile, questions of identity, belonging
and alienation. Now resident in London,
Tabrizian often returns to her country of birth,
but has spoken of feeling like an outsider in both
places. On the one hand, this outsider status
appears to work to her advantage, enabling her
to remain slightly detached from the cultures
she seeks to examine in her imagery. Her
images are often deliberately cold and flat:
landscapes, whether in Iran or elsewhere, are
bleak and the subjects lonely figures within
them. However, in other projects, Tabrizian's
emotional involvement is more evident. Her
2011 travelling exhibition *Another Country*,
for example, examines the complex interaction
between individual and society, with the
subjects in each image representing a particular,
personal predicament, be it a banker in London's
financial district or a veiled woman in Iran.

Tabrizian creates images from both staged
and spontaneous events. While her earlier work
demonstrates her skill for constructed images,
with carefully chosen locations and placed
models, more recent series, such as *Border*,

TOP
tehran suburb west, 2008

BOTTOM
tehran, 2006

OPPOSITE
j.p. morgan, 2008

BELOW
**woman on the bridge
(beyond the limits),
2000–1**

show a more documentary style and approach. Her images remain both cinematic and documentary in form, however, and she places great emphasis on composition, structure and symbolic representation. In the early beginnings when she was taking pictures in Tehran, fascinated by class divisions, Tabrizian came to realize that 'pictures of the poor' were not enough on their own. So she studied critical theories about how to read images, and these teachings have informed her image-making ever since.

Her often deliberately artificial creations reflect on a commodity culture that she clearly finds distasteful. In her series *Beyond the Limits*

(2000–1), she highlights the glamour of the corporate world while exposing its superficial nature. A similar slick aspect and sense of foreboding is evident in the series *The Perfect Crime* (2003–4). Tabrizian creates large-format photographic prints that confront her audience with almost life-size images; held at a distance by the coolness of the image, the viewer is nonetheless involved in assessing the scene.

Having come to photography 'by chance', as she admits, Tabrizian now holds the prestigious title of Professor of Photography at the University of Westminster in London. While she admires the work of eminent photographers such as Robert Frank, Walker Evans, Weegee,

Lee Friedlander and Andreas Gursky, she tries to avoid dwelling on her own projects after completion. 'I do not contemplate much after I finish a project,' she says, 'except for the mistakes I made!' The qualities that make photography an art form are obvious to Tabrizian. In her opinion, photography holds a position in art history that is no less important than painting or sculpture – like all art forms, it provides 'a way of seeing the world differently'. She believes that the enduring appeal of photography is rooted in the idea that 'thinking in images is an older form of thinking – it precedes language'.

Tabrizian's work has been exhibited since the early 1980s in various museums and galleries, ranging from the Photographers' Gallery in London and the Hong Kong Arts Centre to the Museum Folkwang in Essen, Germany, and she was the subject of a solo exhibition at Tate Britain in London in 2008. A book entitled *Another Country* was published to coincide with her travelling exhibition of the same name. Tabrizian's cinematic work has been shown at film festivals in Europe, North America and the Middle East.

nazif topçuoğlu

born: 1953, ankara, turkey

Nazif Topçuoğlu is a Turkish artist who creates highly staged images that resonate with a theatrical and cinematic atmosphere. Taking as his starting point a 'constant preoccupation with time, memory and loss', Topçuoğlu seeks to recreate pictures from an idealized past, which he nonetheless describes as 'unclear and imperfect'. The photographs are replete with art historical references and literary influences from the work of favourite authors such as Thomas Mann and Marcel Proust. Topçuoğlu uses mostly female models in his tableaux: surrounded by lavish period backdrops, they act out roles in stylized compositions that bear resemblance to Old Master paintings. Youth and innocence are frequently contrasted with passivity and aggression, bringing both masculine and feminine qualities to the subjects. The issues of gender roles and the male gaze in traditional art history are important to Topçuoğlu; in his series *Readers*, for example, he seeks to create an image of female youth as a 'gender-free ideal', concentrating on intelligence, beauty and strength. The depiction of female subjects in the act of reading is important to the artist as he feels that in Turkish society women are still disadvantaged when it comes to education.

In Topçuoğlu's work photography holds a dialogue with painting. He studied architecture in Ankara at the Middle East Technical University (METU); having always liked pictures, painting and fine arts, he chose it as 'the closest proper profession'. He also studied photography at the Institute of Design in Chicago and soon abandoned the 'team effort approach' of architecture in favour of photography, which he says 'seemed very

solitary then'. Principally, photography is for Topçuoğlu 'another means of making pictures with artistic intent'. Welcoming what he describes as 'artistic cross-pollination', he wants the medium to be considered not as separate or isolated from other artistic media. Indeed, advising anyone at the start of their photographic career, he would encourage them not to confine themselves to the world of photography and not to 'be tempted by its technological glory'. His admiration of the technology available does not necessarily translate into a wish to use it for his own work,

BELOW
triptych, 2009

however. Describing his style as 'Pictorialist, though not exactly in the original sense of the word', Topçuoğlu asserts that his interest in the history of photography has always been mainy visual, eschewing a close involvement with technique and equipment. While praising innovations such as Photoshop for 'making people realize that photography is only another way of picture-making', he would rather concentrate on the themes and concepts behind the imagery. He is seeking to 'simplify the process, making it more fluid and emphasizing the narrative'.

Starting each project with a clear vision in mind, Topçuoğlu sketches images to create a storyboard from which the photograph will develop. Although he researches details in advance, he nonetheless 'leaves room for accidents to happen', conceding that this is part of the nature of photography. He acknowledges that 'once I start working on an idea, it takes a direction of its own, with each image suggesting the next. The models with their unique talents and sensibilities also suggest new ideas.' Of his recent work he is most proud of the *Triptych* and *Magic Carpet* images, both intricate

OPPOSITE TOP
lamentations, 2007

OPPOSITE BELOW
the anatomy lesson, 2001

compositions with multiple models. He cites the *Readers* series as 'something of a turning point'; he had moved from early commercial work to still lifes with vegetables and meat before turning to these compositions. 'You need to keep in mind that I was doing this in Turkey, when nobody took photography – especially colour photography – seriously in an artistic context,' he says. Rarely working on commission these days, aside from the occasional editorial or advertising assignment, Topçuoğlu is firmly committed to exploring photography as an artistic medium, testing similar themes but

trying to 'push the boundaries further with more mature actors' and approaching something closer to portraiture.

Topçuoğlu's imagery has been shown widely and is held in public and private collections internationally. He has held teaching positions at various universities in Turkey and has produced three books on the history and criticism of photography: *Photographs Only Tease* (2005); *Photography is Not Dead, but Smells Funny* (2000); and *What Makes a Good Photograph?* (1993).

magic carpets, 2010

ruud van empel

born: 1958, breda, netherlands

Ruud van Empel creates striking large-format photomontages – collages of hundreds of photographs, combined to form one photorealistic image. The process takes many weeks and originates with a single idea. Van Empel first takes photographs of models and various settings, then merges them with images from a large database of pictures he has compiled over time, gradually developing a single image. The resulting picture is extremely high resolution, allowing him to obtain large-format prints of extraordinary quality and detail. His inspiration comes from painting but also, crucially, 'from snapshot photography – because that shows real life without any manipulation'. Realism – life 'as it really is' – is a strong theme in his work: 'My ideas need to be expressed in the most realistic way possible.' It is, in fact, this ambition that drew him to photography in the first place. 'I tried painting,' he confesses, 'but the problem was that one always creates a personal style, which is something I do not like.' By his own admission Van Empel did not possess 'the craftsmanship to create realistic painting' and so he turned to photography instead. Painting still has a strong pull for him, however, and he lists artists Edvard Munch and Lucas Cranach, alongside photographers such as Cindy Sherman, among his influences.

Van Empel has won worldwide recognition for his images; asked which project is his favourite, he cites *World*, a series created between 2006 and 2008, depicting children immersed in a 'paradise on earth' (pages 2–3). His stark use of digitally filled-in black and white skin tone has been the subject of some debate, with commentators asking whether the artist was trying to comment on racial politics. Van Empel asserts that race is irrelevant to his work: 'It is the same for me to use a black or a white child – they are both innocent; there is no real difference between them. It is strange to find that some people do not like my use of skin colour.' These photographic series, coherent as they appear when presented in their finished state, are not fully planned in advance. It is during the lengthy process of creating each image that a series begins to develop in the

study for 4 women #2, 2000

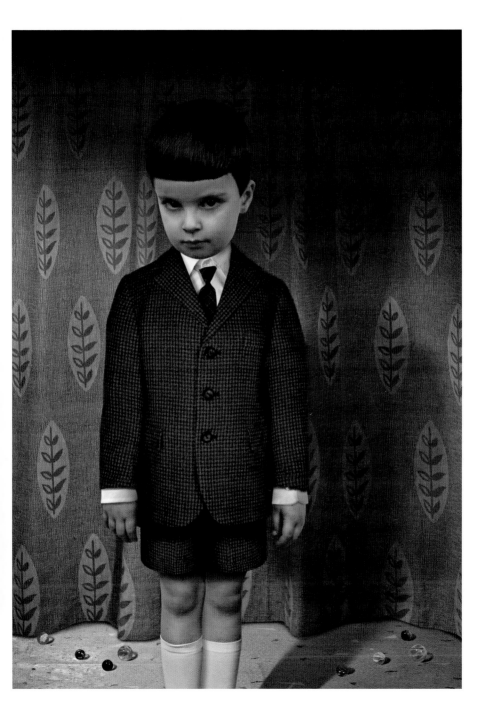

photographer's mind – as he puts it: 'it grows while I am working'. The painstaking process of creating the images has its rewards, bringing successes but also some failures, he admits. 'Sometimes a work fails and I have to find out what I did wrong and start all over again.' The images that survive his scrutiny have been exhibited internationally and are held in collections across Europe, the United States and Asia.

For Van Empel, photography is the most stimulating and malleable medium with which to work. 'Right now photography is leading the market,' he says. 'All new developments in art are taking place in photography.' The invention of Photoshop has provided Van Empel with a tool for developing his own technique and creating his own world, pushing digital production to realize his vision. While his views and ideas have remained largely unchanged throughout his career, his technique gets 'better and better, and I see more possibilities to work with my ideas'. The developments in digital processes excite him with the promise of further possibilities: he envisages a 3-D image that the viewer can appreciate from all angles. Van Empel believes that people love photography because it communicates directly with the audience – 'there is no artistic filter between the viewer and the maker of the image.'

moon #6, 2008

hellen van meene

born: 1972, alkmaar, netherlands

Hellen van Meene is a Dutch photographer best known for her portrayal of adolescent girls in and around her hometown in northern Holland. Capturing her subjects in the period of transition from girl to woman, Van Meene embarked on her first series of portraits when barely out of adolescence herself. Given a camera by her mother when aged fifteen, she took pictures of her friends before developing her hobby into a serious pursuit from the age of eighteen, attending Rietveld Academy in Amsterdam. From her studies in photography the theme of her future work developed 'quite spontaneously and almost intuitively', as the young Van Meene realized she could relate directly to her subjects and 'see in them what I once was'.

Van Meene's images do not have titles as she does not intend them to be portraits of individuals but representations of certain moods and moments. In this way the girls play the part of actors guided by the photographer. Shooting primarily in daylight, Van Meene pays close attention to the composition and staging of the images, arranging everything down to the smallest detail. At the same time, however, she acknowledges the part that chance plays in the photographic process, welcoming the way in which even the most clearly defined idea can change in execution. Working still in what she calls an 'old-fashioned' way, she believes that for her images, negatives still yield better results than digital technology. While she does not work

untitled #338, 2009
('...that ghosts have just as good a right / in every way to fear the light, / as men to fear the dark.' from the poem 'phantasmagoria' by lewis carroll)

untitled #243, london, 2005

OPPOSITE
**untitled #288
(american series), 2007**

untitled #331, st petersburg, russia, 2008

with the collecting market in mind, she does recognize the importance of presentation in the finished result and takes care to ensure that the printing lab works with the best materials.

In 2000, Van Meene was asked by the Japan Foundation to contribute to the Japanese pavilion at the 2001 Architectural Biennale in Venice, with the central theme being 'City of Girls'. She travelled to Japan and found herself confronted with a language and cultural barrier that meant her normal means of communicating with the models did not work. Needing to converse instead 'on the level of trust' proved a challenge. The negotiation of new spaces and light – the latter being crucial to her work – forced Van Meene to look at her imagery from a very different perspective. One senses in her descriptions of her time in Japan that the experience opened up her horizons and left her with a newfound confidence.

While continuing to concentrate on the depiction of young women – a recent project

involved photographing girls in old houses – she also expanded her remit to include images of adolescent boys. One boy called Lawrence, the brother of one her models, whom she first met in 1998 when he was twelve, has been the subject of a series of images that follow him in his development from boy to man. This step into the unknown encouraged the photographer to take another: she wanted to capture the boy alongside her female models, which led her to create portraits of multiple subjects for the first time.

Van Meene has been showing her work in solo and group exhibitions since the mid-1990s both in her home country and internationally. Prints of her images are held in the collections of the Art Institute of Chicago, the Huis Marseille in Amsterdam, the San Francisco Museum of Modern Art and the Victoria and Albert Museum in London.

conservation & display

Photographs are delicate objects and susceptible to damage and degradation. Caring for a collection properly is key to ensuring that it retains value and can be enjoyed for many years to come. Some care instructions are fairly obvious – do not store photographs in direct sunlight or in damp conditions – while others are more unexpected: the Plexiglas used to mount many contemporary photographs, for example, requires specific and special care. It is important for a collector to understand how best to handle, display and store a collection, and to avoid photographs being damaged in any way.

The vast majority of photographs are works on paper, and are composed of two elements: the 'support' – the paper that carries the image – and the 'colloid', the transparent medium that coats the surface of the paper and binds the image. Both have individual properties and act independently of each other, with a determined lifespan due to the nature of the materials themselves. There is also a growing trend among contemporary artists to apply additional media such as oil and acrylic paint, ink and collage elements to photographic prints, which further complicate the make-up of the print and can make it more fragile.

handling

Incorrect handling of photographs is the most common cause of minor damage. As a rule, frequent handling should be avoided unless absolutely necessary. To minimize the possibility of transferring fingerprints or moisture to the print surface it is advisable to wear lint-free cotton or surgical gloves. The print should be picked up by the edges with both hands, and held by the thumbs or sides of the hands with the fingers supporting it underneath. The same applies for handling prints mounted to a card support, as oils from the skin can be transmitted to the card and transfer to the print.

A common mistake is to pick up a print by one corner, causing the weight of the paper to bend the sheet and leave a crease, which if strong enough can crack the surface emulsion of the photograph. Do not place objects on top of prints and, obviously, do not drop them. Seemingly minor superficial issues such as scuffs, scratches and handling creases can significantly alter the value of a print. It is worth remembering that photographs are reproducible: a damaged print of which there are multiple copies will not hold its value against a pristine example of the same image.

mounting

Over the course of the 20th century the nature of photographic practice has changed significantly. Today, the commercial availability of photographic papers combined with technical advances makes it possible to satisfy the increasing demand for ever-larger images – something photographers have been aiming for since the inception of the medium. With size no longer a limitation for contemporary photographers, styles of mounting have also changed. Alongside the more traditional practice of mounting photographic prints on card, large-format prints are now often fixed to aluminium or front-mounted to Plexiglas. While this makes for a sturdier-looking object, the appearance belies its fragile nature. It is much less likely that a print mounted in this fashion will suffer from creasing, but it can still be damaged through improper handling. During transportation, or even hanging, prints are at risk of damage and the Plexiglas surface can be scratched. As it is difficult to remove a print from Plexiglas, any damage to the mounting must be considered as damage to the print itself and will materially affect both value and appearance.

light

Light is a vital ingredient in the creation of photographs but it can also cause a great deal of damage to prints. The light-sensitive materials that are used to form the image, although stabilized once the image is processed, remain susceptible to change and degradation if proper care is not taken. Overexposure to light can cause discolouration, fading and materials to become brittle. Short-wavelength light (towards the ultraviolet end of the spectrum) is the most damaging. Unfortunately, such rays are found in abundance in natural light, so you should never hang a photograph in direct sunlight. Fluorescent lighting should also be avoided, although filters can be added to light fixtures to remove most of the ultraviolet radiation. In addition ultraviolet-shielding Plexiglas can be used for the frame instead of glass.

Light damage is an interesting area of debate with regard to contemporary photography, as the majority of work made by photographers today is in colour. When colour was first commonly used in the 1970s, many collectors were sceptical of this new process and unsure how prints would stand the test of time. As early as 1979, Henry Wilhelm, who has conducted extensive research into the subject of colour permanence for thirty years, wrote of collectors' reluctance to spend money on colour prints because of their alleged lack of permanence. The dyes used in the colour processes are sensitive to damage by light, and it is true that some colour prints made in the 1970s and later have already started to show signs of discolouration. Manufacturers have worked hard, however, to bring their products in line with the archival standards demanded by the market, improving paper bases (Fuji's 'Crystal Archive' paper, for example) and developing inkjet materials made from pigments rather than dyes. Manufacturers continue to conduct research in this area; there is extensive information available from Wilhelm Imaging Research (see www.wilhelm-research.com).

pollutants

Photographic prints are at risk from general atmospheric pollutants and from non-archival materials with which they may come into contact.

The most widespread atmospheric pollutant is sulphur dioxide, which, when combined with oxygen, becomes sulphuric acid, a corrosive substance that can discolour prints and render them brittle. Fumes from solvents, fresh paint, vehicle exhausts and certain adhesives pose a threat, while airborne dust particles can also act as an abrasive if they settle on the surface of a print that then rubs against another surface. Great care must be taken when removing dust that has settled on Plexiglas surfaces: a swift wipe with a cloth or duster can do far more harm than good. All materials with which photographic prints come into contact, in storage, mounting or display, must be acid-free. A wide range of archival materials is now available to the collector.

residual chemicals

As early as 1855, in a report from the Royal Photographic Society committee, poor fixing and poor washing were cited as two important causes of degradation in photographic prints. Sodium thiosulphate, or 'hypo', is a solvent used to fix an image at the desired point of development by removing any remaining light-sensitive materials such as silver that would otherwise carry on reacting. Residual chemicals left on the print by improper fixing or incomplete washing will yellow and eventually fade the image. In the case of silver prints, complex silver compounds left by inadequate fixing will yellow the highlights or areas of lighter tone. With badly fixed prints these issues are inherent from the moment of production (they are essentially flaws in the object) but the damage may take years to become apparent.

temperature and humidity

Photographs can be damaged if temperature and humidity are too high or too low. Low humidity can cause brittleness and cracking, but high humidity is often the greater danger. It causes mould to thrive, which feeds off the nutrients in the starch of the paper, the adhesives used to fix prints to mounts, or the gelatin emulsion used to create the image. Common damage caused by high humidity includes the appearance of rust-coloured spots (known as 'foxing'), fading due to oxidization of silver in prints, and the curling of print edges.

It has been recognized that low-temperature storage has benefits for the long-term stability of photographic prints, as it slows the rate of chemical change. In order to aid preservation some institutions have gone as far as freezing their archives of prints and negatives. The first cold-storage vaults for colour collections came into use around 1975 and were shown to reduce fading in prints significantly. The complicated and expensive construction of these vaults, however, means that they are not a feasible option for most private collectors and the process by which the cold-stored prints are 'warmed up' again is also complex and best handled by experts.

In general, museum conservation standards recommend a constant temperature of 18 degrees Celsius (64.4 F) and 40 per cent relative humidity. For the individual collector, safe levels to aim for are temperatures no higher than 21 degrees Celsius (69.8 F) and humidity no higher than 60 per cent. Consistency is key, as extreme fluctuations will lead to damage.

display and storage

The effect of heat and humidity should also be kept in mind when considering where and how to display photographs. Prints should never be stored or displayed near radiators, heating pipes and fireplaces or in cold or damp cellars and attics. For most collectors, framing with glass or Plexiglas is the ideal way to display prints. Modern mountings for large-scale contemporary works may involve the artist bonding a Plexiglas face to the print surface. Other modern framing methods hold the print uncovered in the frame. In both cases, care needs to be taken to avoid damage to the work hanging on the wall, as marks on the print or Plexiglas surface could be irreparable. The frequent rotation of photographs on display is practised by institutions and collectors alike: it is beneficial as it avoids any one print remaining exposed for too long. It is also an enjoyable way of revisiting your collection and seeing images afresh.

Prints that remain unframed are generally more vulnerable and prone to damage. The basic means of protection is to place them in archival card window mounts, but should you decide against this because of space restrictions, prints can also be stored in special archival sleeves made from transparent materials like polyethylene or polyester. In fact, even photographs in window mounts will benefit from a sheet of a transparent material being placed over the surface before the mount is closed. Unframed prints protected in this manner can be stored in archival boxes, portfolios or plan chests. Prints of similar size and weight should be kept together but never in a large stack where the weight of the pile can cause damage.

restoration

Photographic conservation and restoration is an established and common practice, with independent and full-time conservators being employed by major institutions and collectors to care for their collections. It is vital to use a professional restorer; galleries and auction houses will be able to make recommendations. It is important to be aware that restoration is sometimes seen as a contentious issue, as it can be deemed to alter the integrity and authenticity of the original artwork. A collector buying a restored print should be alerted to any work that has been done to it and understand why this was necessary. For those looking to sell a photograph that might benefit from restoration, it is important to recognize that many buyers may prefer to take decisions regarding restoration themselves after the purchase has been made.

In all cases prevention is better than cure. An awareness of the issues raised here is a vital part of any collector's understanding and appreciation of photographs. Careful conservation and storage of these fragile objects will extend their lifespan and the pleasure you can gain from them.

biographies

prices

$ $500–1,600 / £300–1,000
$$ $1,600–8,200 / £1,000–5,000
$$$ $8,200–16,400 / £5,000–10,000
$$$$ $16,400–82,000 / £10,000–50,000
$$$$$ $82,000–165,000 / £50,000–100,000
$$$$$+ above $165,000 / £100,000

miles aldridge

education
Central Saint Martins College of Art
& Design, London

exhibitions include
2006 'The Cabinet', Reflex Gallery,
 Amsterdam
2008 'Acid Candy', Reflex Gallery,
 Amsterdam
2009 'Pictures for Photographs',
 Steven Kasher Gallery, New York
 'Doll Face', Hamiltons Gallery,
 London
 'Weird Beauty: Fashion
 Photography Now',
 International Center of
 Photography, New York
2010 '13 Women', Studio for the Arts,
 Berlin
 'New Work', Brancolini
 Grimaldi, Florence

representation
Hamiltons Gallery, London
Reflex Gallery, London

www.milesaldridge.com
$$–$$$$

benoit aquin

education
New England School of Photography,
Boston, Mass.

exhibitions and collections include
2010 'Chinese Dust Bowl', Stephen
 Bulger Gallery, Toronto
 'Haïti après le séisme',
 Galerie Pangée, Montreal
 Prix Pictet Laureates,
 Musée de l'Elysée, Lausanne
 Canadian Museum of
 Contemporary Photography,
 Ottawa
 Musée national des beaux-arts
 du Québec, Québec City

awards include
2006 Prix Antoine-Desilets, Federation
 of Quebec Journalists
2008 Prix Pictet

representation
Polaris Images, New York
Stephen Bulger Gallery, Toronto

www.benoitaquin.com
$–$$$

olivo barbieri

education
University of Bologna, Italy

exhibitions include
2006 Museum of Contemporary
 Art, Cleveland, Ohio
2008 San Francisco Museum of
 Modern Art, Calif.
2011 'Dolomites Project 2010',
 Museo di arte moderna e
 contemporanea di Trento
 e Rovereto

representation
Yancey Richardson Gallery,
New York

www.olivobarbieri.it
$$–$$$$

peter beard

education
Yale University, New Haven, Conn.

exhibitions include
1996 'Carnets Africains', Centre
 National de la Photographie,
 Paris
1998 'Fifty Years of Portraits',
 Gallery One, Toronto
 (also touring)
2010 'Elephant Parade', Somerset
 House, London

representation
Michael Hoppen Gallery, London
The Time is Always Now Gallery,
New York

www.peterbeard.com
$$–$$$$$+

jonas bendiksen

exhibitions include
2002 'Changing the Face of India',
 Tom Blau Gallery, London
2004 'Moving Walls 8', Open Society
 Institute, New York
2006 'Satellites', Jewish Historical
 Museum, Amsterdam

awards include
2003 Infinity Award, Young
 Photographer of the Year,
 International Center of
 Photography, New York
2007 ASME National Magazine
 Award
 Award of Excellence, Pictures
 of the Year International
2008 Telenor International Culture
 Award

representation
Magnum

www.jonasbendiksen.com
$–$$$

elina brotherus

education
University of Art and Design,
 Helsinki

exhibitions include
2002 INOVA, Milwaukee, Wis.
2008 The National Art Center,
 Tokyo
2010 Bloomberg SPACE, in the
 'Comma' series, London
 Retrospective, gb agency,
 Paris

awards include
2005 Prix Niépce, Gens d'images
2008 Finnish State Prize for
 Photography

representation
Wapping Project Bankside, London
Martin Asbaek, Copenhagen

www.elinabrotherus.com
$$–$$$$

edward burtynsky
education
Ryerson University, Toronto

exhibitions include
2005 'China', Southeastern Center
for Contemporary Art,
Winston-Salem, N.C.
(three-year touring show)
2009 Oil, Corcoran Gallery of Art,
Washington DC, (five-year
touring show)

awards include
2004 Outreach Award,
Les Rencontres de la
Photographie, Arles, France
2005 TED (Technology, Entertainment
& Design) Prize

representation
Nicholas Metivier Gallery, Toronto
Paul Kuhn Gallery, Calgary
Art 45, Montreal
Hasted Kraeutler Gallery, New York
Sundaram Tagore Gallery, Hong Kong
Flowers Gallery, London
Galeria Toni Tàpies, Barcelona
Galerie Stefan Röpke, Cologne

www.edwardburtynsky.com
$$–$$$$

kelli connell
education
Texas Woman's University, Denton, Tex.
University of North Texas, Denton, Tex.

exhibitions include
2007 Yossi Milo Gallery, New York
'Kiss and Tell', Center for
Photography at Woodstock,
New York
2009 Catherine Edelman Gallery,
Chicago, Ill.

awards include
2003 Dallas Museum of Art
Kimbrough Award
2004 Finalist, Emerging American
Photographer Award
2005 Top 50 Photographers, Critical
Mass 2005, Photo Lucida

representation
Yossi Milo Gallery, New York
Weinstein Gallery, Minneapolis, Minn.
Catherine Edelman Gallery, Chicago, Ill.
Barry Whistler Gallery, Dallas, Tex.

www.kelliconnell.com
$–$$$

gregory crewdson
education
Yale School of Art, Yale University,
New Haven, CT

exhibitions include
2006 'Gregory Crewdson: Fotografien
1985-2005', Fotomuseum
Winterthur, Switzerland
(also touring)
2011 Kulturhuset Museum,
Stockholm (also touring)

awards include
2004 Skowhegan Medal for
Photography
National Endowment for the
Arts
Visual Artists Fellowship
Aaron Siskind Fellowship

representation
White Cube, London
Gagosian, London

www.crewdsonstudio.com
$$–$$$$$

denis darzacq
education
L'Ecole Nationale Supérieure des Arts
Décoratifs, Paris

exhibitions include
2005 Bobigny Centre Ville, Les
Rencontres de la Photographie,
Arles, France
2008 'Hyper/Casques', Perth Centre
for Photography, Perth
2009 Denis Darzacq, Australian
Centre for Photography,
Sydney
2011 'Hyper', Contact Photography
Festival, Ottawa

awards include
2007 First Prize, stories category,
World Press Photo

representation
Galerie VU, Paris
Laurence Miller Gallery, New York
De Soto Gallery, Los Angeles, Calif.
Goddard de Fiddes Gallery, Perth

www.denis-darzacq.com
$–$$$

tacita dean
education
Slade School of Fine Art, London
Supreme School of Fine Art, Athens

exhibitions include
2007 Guggenheim Museum, New York
2010 Craneway Event, Frith Street
Gallery, London
2011 Unilever Commission, Turbine
Hall, Tate Modern, London

awards include
2005 Bennesse Prize, Venice Biennale
2008 Günter-Fruhtrunk Prize, Munich
2009 Kurt Schwitters-Preis Award

representation
Frith Street Gallery, London
Marion Goodman Gallery, New York
and Paris

www.tacitadean.net
$–$$$

philip-lorca dicorcia
education
Yale University, New Haven, Conn.
School of Museum of Fine Arts,
Boston, Mass.

exhibitions include
2007 Institute of Contemporary Art,
Boston, Mass.
2009 'Family & Friends', Manezh
Exhibition Hall, Moscow

awards include
1998 Alfred Eisenstaedt Award,
Life Magazine, Style Essay
2001 Infinity Award for Applied
Photography, International
Center of Photography,
New York

representation
Sprüth Magers, London and Berlin
David Zwirner Gallery, New York
Galerie Rodolphe Janssen, Brussels
Galleria Monica de Cardenas, Milan

$$$–$$$$$

ahmet ertug
education
Architectural Association School of
Architecture, London

exhibitions include
2006 'Vaults of Heaven: Sanctuaries of
Byzantium', World Monuments
Fund Gallery, New York
2008 'Ephesos: Architecture,

Monuments & Sculpture',
Ephesos Museum (KHM),
Vienna
2009 'Libraries: Temples of
Knowledge', Bibliothèque
Nationale de France, Paris

representation
Polka Galerie, Paris

www.ahmetertug.com
$$$-$$$$

julia fullerton-batten
education
Berkshire College of Art and Design,
Windsor, UK

exhibitions include
2006 'A Picture of Health',
National Portrait Gallery, London
2007 Photography Biennial,
Guangdong Museum of Art,
China
2008 'Unseen', Museum of
Contemporary Art, Shanghai
'Teen City: The Adolescent
Adventure', Musée de l'Elysée,
Lausanne, Switzerland
2010 'Dreamlands', Centre Pompidou,
Paris

awards include
2006 VIPC Woman (Venice
International Photography
Contest)
2007 Fondation HSBC pour la
photographie
2008 Hasselblad Master in Fine Art

representation
Eric Franck Fine Art, London

www.juliafullerton-batten.com
$$-$$$

stephen gill
education
Filton College, Bristol, UK

exhibitions include
2003 'Hackney Flowers',
Photographers' Gallery, London
2004 'Field Studies', State Centre
of Architecture, Moscow
2007 'Anonymous Origami and
Buried', Leighton House
Museum, London
2010 'Coming Up for Air', GP Gallery,
Tokyo
2011 'Outside In', Gun Gallery,
Stockholm

awards include
2006 Vic Odden Award
2008 Photography Book of the Year,
The Times, for *Hackney Flowers*
2009 Best Books, Photo Eye, for
A Series of Disappointments

representation
Gun Gallery, Stockholm

www.stephengill.co.uk
$-$$$

aneta grzeszykowska
education
Academy of Fine Arts, Warsaw

exhibitions include
2005 Robert Mann Gallery, New York
2006 Polish Cultural Institute, Berlin
2007 'At Last, Something New!',
The National Museum,
Krakow, Poland
2007 'Untitled Film Stills', Raster at
Art Statements, Art Basel
2010 Heidelberger Kunstverein,
Heidelberg, Germany

awards include
2005 Deutsche Bank Cultural
Foundation Award

representation
Raster Gallery, Warsaw
Galerie Nächst St Stephan, Vienna

$-$$$

sunil gupta
education
Royal College of Art, London
West Surrey College of Art & Design,
Farnham, UK

exhibitions include
2005 'Sunil Gupta', Canadian
Museum of Contemporary
Photography, Ottawa
2009 'Imagining Childhood', Sepia,
New York

awards include
2000 Canada Book Council Award
for publishing, for *The New
Republics: Contemporary Art
from Australia, Canada and
South Africa*
2001 Diversity Project, Arts Council
of England
2002 AHRB Fellowship in Creative &
Performing Arts, University of
Southampton, UK

representation
Galerie Caprice Horn, Berlin
Stephen Bulger Gallery, Toronto
Vadehra Art Gallery, New Delhi
Sepia EYE, New York

www.sunilgupta.net
$$-$$$

naoya hatakeyama
education
University of Tsukuba, Japan

exhibitions include
2002 'Naoya Hatakeyama',
Kunstverein Hannover,
Kunsthalle Nürnberg and
Huis Marseille, Amsterdam
2004 Cultural Forum for Photography,
Berlin
2007 'Artists Today XI', Museum of
Modern Art, Kamakura, Japan
2010 'Terrils', Centre Historique
Minier de Lewarde, France

awards include
2003 Photographer of the Year Award,
Photographic Society of Japan

representation
Michael Hoppen Gallery, London
Taka Ishii Gallery, Tokyo
L.A. Galerie Lothar Albrecht,
Frankfurt

$-$$$$

bill henson
education
Prahran College of Advanced
Education, Melbourne

exhibitions include
2005 'Bill Henson: Three Decades of
Photography', Art Gallery of
New South Wales, Sydney,
and National Gallery of
Victoria, Melbourne
2007 Institute of Modern Art,
Brisbane
2010 'Bill Henson: Early work from
the Monash Gallery of Art
Collection' (travelling
exhibition)

representation
Roslyn Oxley9, Sydney
Robert Miller Gallery, New York
Gould Galleries, South Yarra

www.billhenson.net.au
$$-$$$$

zhang huan
education
Central Academy of Fine Arts, Beijing
Henan University, Kaifeng, China

exhibitions include
2005 'Seeds of Hamburg', Museum
of Fine Arts, Boston, Mass.
2008 'Altered States', Vancouver Art
Gallery
2010 'Dawn of Time', Shanghai Art
Museum
2011 'Q Confucius', Rockbund Art
Museum, Shanghai

representation
Pace Gallery, New York
Chambers Fine Art, New York/Beijing
Nou Gallery, Taipei City
Friedman Benda Gallery, New York
Principal Art, Barcelona

www.zhanghuan.com
$$–$$$$$+

tom hunter
education
Royal College of Art, London
London College of Printing, London

exhibitions include
2005 'Living in Hell and Other Stories',
National Gallery, London
2008 'Life and Death in Hackney',
Fotografins Hus, Stockholm
'Interior Lives', Geffrye
Museum, London
2009 'Flashback', Museum of London
2010 'A Palace for Us', Serpentine
Gallery, London

awards include
2003 John Kobal Book Award
2010 Honorary Fellowship, Royal
Photographic Society

representation
Purdy Hicks Gallery, London
Yancey Richardson Gallery, New York
Marine Contemporary, Los Angeles,
Calif.
Green on Red Gallery, Dublin

www.tomhunter.org
$–$$$$

nadav kander
exhibitions include
2009 'Obama's People', Birmingham
Museum and Art Gallery, UK
2010 'Prix Pictet Laureates',
Palais de L'Elysée, Lausanne,
Switzerland
2010 'Obama's People', Kunsthallen
Nikolaj, Copenhagen
2011 'Inner Condition, Portraits and
Obama's People', Centro
Andaluz de la Fotografia,
Almería, Spain

awards include
2009 International Photographer of the
Year, Lucie Awards, New York
Prix Pictet

representation
Pekin Fine Arts, Beijing
Camera Work, Berlin
Flowers Galleries, London
M97 Gallery, Shanghai

www.nadavkander.com
$–$$$$

izima kaoru
exhibitions include
2005 'f a projects', London
2006 Studio La Città, Verona
2007 'Early Series', Kudlek van der
Grinten Galerie, Cologne
2008 Von Lintel Gallery, New York
2010 Galerie Andreas Binder, Munich

representation
Kudlek van der Grinten Galerie, Cologne
Von Lintel Gallery, New York

$$–$$$$

rinko kawauchi
education
Seian University of Art and Design,
Shiga, Japan

exhibitions include
2007 'Aila and The Eyes, The Ears',
Fotografins Hus, Stockholm
2008 'Cui Cui', Vangi Sculpture
Garden Museum, Shizuoka
2009 ARGOS Centre for Art and
Media, Brussels
2010 'Rinko Kawauchi: Transient
Wonders, Everyday Bliss –
Photography, Video & Slides'

awards include
2002 'Rookie of the Year' Award,
Photographic Society of Japan

2009 Annual Infinity Award,
International Center of
Photography, New York

representation
Galerie Priska Pasquer, Cologne
Foil Gallery, Tokyo

$–$$$$

idris khan
education
Royal College of Art, London
University of Derby, UK

exhibitions include
2006 'A Memory After Bach's Cello
Suites', Film Installation,
Yvon Lambert Gallery, Paris
2007 Galerie Thomas Schulte, Berlin
2008 'Every...', K20, Düsseldorf
2009 Elementa, Dubai
2010 'Idris Khan: Last 3 Piano
Sonatas...after Franz Schubert',
I.D.E.A. Space, Colorado
College, Colorado Springs, Colo.
'Idris Khan', Victoria Miro
Gallery, London

awards include
2002 Tom Gower Award, The British
Institute of Photography
2004 The Photographers' Gallery Prize,
London

representation
Victoria Miro Gallery, London
Galerie Yvon Lambert, Paris
Fraenkel Gallery, San Francisco, Calif.
Galerie Thomas Schulte, Berlin

$$–$$$$

edgar martins
education
Royal College of Arts, London
London Institute, London

exhibitions include
2005 'The Diminishing Present',
Photographers' Gallery,
London
2007 'Topologies', Centro de Artes
Visuais, Coimbra, Portugal
2010 'Edgar Martins', Centre Culturel
Calouste Gulbenkian, Paris
2011 'The Time Machine: An
Incomplete & Semi-Objective
Survey of Hydro Power Plants',
Museu da Electricidade,
Lisbon
2012 'This Is Not A House',
Wapping Project, London

awards include
2008 New York Photography Award,
 Fine Art Category
2009 BES Photo Prize

representation
Galerie Caprice Horn, Berlin
Galeria Laura Marsiaj, Rio de Janeiro

www.edgarmartins.com
$-$$$

richard misrach

education
University of California, Berkeley, Calif.

exhibitions include
2002 'Richard Misrach: Berkeley
 Work', Berkeley Art Museum
2008 'Time is of the Essence:
 Contemporary Landscape
 Art', Asheville Museum, N.C.

awards include
2002 Cultural Award for Lifetime
 Achievement, German
 Photographic Association

representation
Pace/MacGill Gallery, New York
Fraenkel Gallery, San Francisco, Calif.
Robert Mann Gallery, New York

$$-$$$$

stephen j. morgan

exhibitions include
2005 'The Morgans: I was born an
 English Catholic', The
 Wapping Project, London
2006 'Four Stages for People',
 Birmingham Central Library
2010 'Photographs 2002–2010',
 Wapping Project, London
2011 Galerie Brissot, Paris
 'Tales from the North', Photon,
 Ljubljana, Slovenia

representation
Wapping Project Bankside, London

www.stephenjmorgan.com
$-$$$

youssef nabil

education
Ain Shams University, Cairo

exhibitions include
2003 'Pour un Moment d'Eternité',
 Rencontres de la Photographie,
 Arles, France
2009 'I Live Within You', Savannah
 College of Art and Design,
 Atlanta, Ga.
 'I Won't Let You Die', Villa
 Medici, Rome

awards include
2003 Seydou Keita Prize for Portraiture,
 Rencontres Africaines de la
 Photographie, Bamako, Mali

representation
Yossi Milo Gallery, New York
Galerie Nathalie Obadia, Paris

www.youssefnabil.com
$$-$$$$

simon norfolk

education
University of Wales, Newport, UK
Oxford University, UK
Bristol University, UK

exhibitions include
2002 'Afghanistan: Chronotopia',
 Minneapolis Center for
 Photography (also touring)
2005 'Eastern Bosnia and Northern
 Normandy', Photographers'
 Gallery, London
2006 'Et in Arcadia ego', Russian
 Academy of Fine Arts, Moscow
2008 'Simon Norfolk: A Retrospective',
 Museo de Arte Contemporáneo
 de Unión Fenosa, La Coruña,
 Spain

awards include
2001 World Press Award
2002 European Publishers' Award
 for *Afghanistan: Chronotopia*
2004 Infinity Award, International
 Center of Photography, New York
2006 'Document' Prize and Silver
 Award, Association of
 Photographers

representation
Michael Hoppen Gallery, London
Gallery Luisotti, Santa Monica, Calif.
Bonni Benrubi Gallery, New York
McBride Fine Art, Antwerp, Belgium

www.simonnorfolk.com
$$-$$$$

martin parr

education
Manchester Polytechnic, UK

exhibitions and collections include
2002 'Martin Parr Photographic Works
 1971–2000', Barbican Art
 Gallery (also touring)
2003 National Museum of
 Photography, Copenhagen
2007 Retrospective, Kulturhuset,
 Stockholm
2009 'Planète Parr', Jeu de Paume, Paris

awards include
2005 Honorary FRPS, Royal
 Photographic Society
2006 International Photography Prize,
 Moscow House of Photography
2008 Lifetime Achievement Award,
 Photo España
2008 Centenary Award, Royal
 Photographic Society
2008 International Award for
 contribution towards
 promoting Japanese
 photographic book publishing,
 Photographic Society of Japan

representation
Magnum
Janet Borden, New York
Rocket Gallery, London
Galerie Kamel Mennour, Paris
Galerie Asbaek, Copenhagen
Rose Gallery, Santa Monica, Calif.

www.martinparr.com
$-$$$$

alex prager

exhibitions include
2007 'Polyester', Robert Berman
 Gallery, Santa Monica, Calif.
2007 'Safe+Sound', Institute of
 Fashion, London
2008 'The Big Valley', Michael Hoppen
 Gallery, London, and Yancey
 Richardson, New York (2009)
2010 'New Photography', Museum of
 Modern Art, New York
 'Weekend', M+B Gallery, Los
 Angeles, Michael Hoppen
 Gallery, London, and Yancey
 Richardson Gallery, New York

representation
Michael Hoppen Gallery, London
M+B Gallery, Los Angeles, Calif.
Yancey Richardson Gallery, New York

www.alexprager.com
$$-$$$

wang quingsong

education
Sichuan Fine Arts Institute, China

exhibitions and collections include
2007 'China: Past, Present and
 Future', MEWO Kunsthalle,
 Memmingen, Germany
2008 'Wang Qingsong: Temporary
 Ward', BALTIC Centre for
 Contemporary Art,
 Gateshead, UK
2009 Hammer Museum, Los Angeles,
 Calif.
2010 'Wang Qingsong: Follow Me',
 Centro Andaluz de la
 Fotografía, Almería, Spain

awards include
2006 Outreach Award, Les Rencontres
 de le Photographie, Arles, France

representation
Pekin Fine Arts, Beijing
Galería Dolores de Sierra, Madrid

www.wangqingsong.com
$$-$$$$$+

ed ruscha

education
Chouinard Art Institute (California
Institute of the Arts), Los Angeles, Calif.

exhibitions include
2005 'Ed Ruscha and Photography',
 Whitney Museum of American
 Art, New York
2007 'Ed Ruscha, Photographer', Jeu
 de Paume, Paris (also touring)
2009 'Ed Ruscha: Fifty Years of
 Painting', Hayward Gallery,
 London (also touring)

awards include
2008 Aspen Award for Art
2009 National Arts Award for Artistic
 Excellence

representation
Gagosian

www.edruscha.com
$-$$$$$+

alec soth

exhibitions include
2005 Minneapolis Institute of Arts,
 Minn.
2006 California Museum of
 Photography, Riverside, Calif.
2008 Jeu de Paume, Paris, and
 Fotomuseum Winterthur,
 Switzerland

awards include
2006 Golden Light Award
2008 Photo Vision Award
2011 Infinity Award for Publication,
 International Center of
 Photography, New York

representation
Magnum
Weinstein Gallery, Minneapolis, Minn.
Sean Kelly Gallery, New York
Loock Galerie, Berlin

www.alecsoth.com
$$-$$$$

thomas struth

education
Academy of Fine Arts, Düsseldorf

exhibitions include
2002 Metropolitan Museum of Art,
 New York (also touring)
2007 'Making Time', Prado, Madrid
2011 'Thomas Struth: Photographs
 1978–2010', Whitechapel
 Gallery, London (also touring)

representation
Marian Goodman Gallery, New York
Galerie Max Hetzler, Berlin

$$-$$$$$+

mitra tabrizian

education
Polytechnic of Central London
(University of Westminster), London

exhibitions include
2006 Museum of Modern Art,
 Stockholm
2008 Tate Britain, London
2010 '21st Century', Queensland
 Gallery of Modern Art, Brisbane

awards include
1993 Greater London Arts Film Award

representation
Galerie Caprice Horn, Berlin
Project B, Milan

www.mitratabrizian.com
$$-$$$$

nazif topçuoğlu

education
Institute of Design, Chicago
Middle East Technical University,
Ankara, Turkey

exhibitions include
2005 kunst:raum Sylt Quelle, Germany
2006 Russian Photography Biennale
2009 'A Subjective Panorama of

Contemporary Turkish
 Photography', Maison des
 Métallos, Paris
2010 'Simulacres et Parodies', Galerie
 de Photographie d'art du
 Château d'Eau, Toulouse

representation
Flatland Gallery, Utrecht, Netherlands
Galeri Nev, Istanbul

www.naziftopcuoglu.com
$$-$$$$

ruud van empel

education
Academy of Fine Arts St Joost, Breda,
Netherlands

exhibitions include
2007 Museum Het Valkhof, Nijmegen,
 Netherlands
2008 CB Collection Roppongi, Tokyo
2010 Noord-Brabants Museum,
 Hertogenbosch, Netherlands
2012 Museum of Photographic Arts,
 San Diego, Calif.

awards include
2001 H.N. Werkman Prize

representation
Flatland Gallery, Utrecht, Netherlands
Stux Gallery, New York
Galerie TZR, Düsseldorf

www.ruudvanempel.nl
$$-$$$$$

hellen van meene

education
Gerrit Rietveld Academie, Amsterdam
College of Art, Edinburgh

exhibitions include
2006 Huis Marseille, Amsterdam
 Tokyo Wonder Site, Shibuya
 Open Eye Gallery, Liverpool
 Maison Européenne de la
 Photographie, Paris
2007 Fotografins Hus, Stockholm
 Museum Folkwang, Essen,
 Germany
2010 FO.KU.S Foto Kunst Stadtforum,
 Stadtforum, Innsbruck, Austria

awards include
2001 Nominee, Citibank Private
 Bank Photography Prize

representation
Yancey Richardson Gallery, New York
Sadie Coles HQ, London
Gallery Koyanagi, Tokyo

www.hellenvanmeene.com
$-$$$

galleries & private dealers

The list below is by no means exhaustive but will serve as a useful introduction to the breadth of commercial galleries exhibiting and selling contemporary photography across the world today. While some of those listed focus solely on photography, others represent artists working in a variety of media.

australia
Roslyn Oxley9 Gallery
8 Soudan Lane
Paddington
Sydney
New South Wales 2021
www.roslynoxley9.com.au

Founded in 1982, this Sydney gallery is committed to the promotion of innovative contemporary art. Currently representing more than thirty artists, it exhibits a wide range of media, including painting, sculpture, photography, performance art, installation and video.

Gould Galleries
270 Toorak Road
South Yarra, Victoria 3141
www.gouldgalleries.com

Established by art specialist Rob Gould, this gallery has been trading for over thirty years, with a special focus on Australian art.

austria
Galerie Johannes Faber
Dorotheergasse 12
1010 Vienna
www.jmcfaber.at

The Faber gallery was founded in 1983 and represents a wide range of artists. It specializes in Czech and Austrian photography as well as classic and contemporary American works.

Galerie nächst St. Stephan Rosemarie Schwarzwälder
Grünangergasse 1
1010 Vienna
www.schwarzwaelder.at

Located in the same district of Vienna since the 1920s, this gallery is dedicated to modern art and represents artists working with painting, video, installation and photography.

belgium
Young Gallery
Avenue Louise 75B
Wiltcher's Place
1050 Brussels
www.younggalleryphoto.com

Pascal Young opened his first gallery in June 2000 and has since developed relationships with a long list of contemporary photographers and artists, both established names and new talents. Featured artists include Nobuyoshi Araki, Peter Beard, Edward Burtynsky, Patrick Demarchelier, Joseph Hoflehner and Ellen von Unwerth. The gallery has a second space in Knokke.

Xavier Hufkens
Sint-Jorisstraat 6–8 Rue Saint-Georges
1050 Brussels
www.xavierhufkens.com

Founded in 1987, Xavier Hufkens gallery represents about thirty artists from a range of backgrounds and disciplines, and exhibits the work of various photographers including Roger Ballen, William Eggleston and Adam Fuss.

André Simoens Gallery
Kustlaan 128–130
B-8300 Knokke
www.andresimoensgallery.com

Founded in 1978, André Simoens is a post-war and contemporary art gallery that has also promoted contemporary photography since the 1990s. The gallery has shown work by Martin Parr, Hiroshi Sugimoto, Jack Pierson and Andres Serrano among others.

Fifty One Fine Art Photography
Zirkstraat 20
2000 Antwerp
www.gallery51.com

Fifty One Fine Art Photography specializes in African photography, and vintage and fashion images.

Founded in 2000, the gallery supports both established and emerging photographers and is the largest gallery in Belgium devoted exclusively to photography. An office space was opened in New York in 2009 to cater for the gallery's expanding American client base.

brazil
Laura Marsiaj Arte Contemporânea
Rua Teixeira de Melo, 31c
Ipanema 22410-010
Rio de Janeiro
www.lauramarsiaj.com.br

Laura Marsiaj Arte Contemporânea opened in 2000 and supports contemporary Brazilian and international artists. In 2005 the gallery opened a second space with the idea of showing more experimental works. The gallery exhibits photography, painting, installations, sculpture, video and site-specific works.

canada
Stephen Bulger Gallery
1026 Queen Street West
Toronto, Ontario M6J 1H6
www.bulgergallery.com

Stephen Bulger Gallery was founded in 1994 and works with established and emerging contemporary photographic artists. The gallery has a stock of approximately 15,000 photographs and welcomes first-time buyers as well as established collectors.

Corkin Gallery
55 Mill St, Bldg 61
Toronto, Ontario M5A 3CA
www.corkingallery.com

Corkin Gallery holds a wide range of historical and fine-art photographs from the 19th and 20th centuries alongside a strong contemporary programme and works with international artists in its five exhibition spaces.

Art 45
372 Sainte-Catherine Street West #220,
Montreal, Quebec
www.art45.ca

Art 45 is a contemporary gallery
showing a select number of artists,
including photographers Edward
Burtynsky, André Kertész, Robert
Polidori and Deborah Turbeville.

china
Pekin Fine Arts
Chao Yang District
Cui Ge Zhuang
No. 241 Cao Chang Di Village
100015 Beijing
www.pekinfinearts.com

Pekin Fine Arts was founded in 2005
and boasts a large gallery space
designed by contemporary artist Ai
Wei Wei. A private consultancy and art
gallery, it acts as adviser to museums
and corporations as well as individuals,
and represents a wide variety of Asian
artists who work in different media and
exhibit nationally and internationally.

M97 Gallery
No. 97 Moganshan Road, 2nd floor
200060 Shanghai
www.m97gallery.com

One of the first galleries dedicated
to contemporary and fine-art
photography in Shanghai, M97 was
established in 2006 and is one of
the largest photographic galleries
in China, representing over twenty
photographers including Nadav
Kander and Michael Wolf.

denmark
Martin Asbaek Gallery
Bredgade 23
1260 Copenhagen
www.martinasbaek.com

Martin Asbaek Gallery was established
in 2005 and supports both Scandinavian
and international artists, including
renowned photographer Elina
Brotherus.

finland
Galleria Pirkko-Liisa Topelius
Ulla Linnankatu 1 A 2-4
00130 Helsinki
+358 9 643452

This 56-square-metre gallery exhibits
works by a range of artists, focusing in
particular on up-and-coming names.

france
Galerie Yvon Lambert
108, rue Vieille du Temple
75003 Paris
www.yvon-lambert.com

Galerie Yvon Lambert represents more
than fifty international artists working
in a range of media. Featured
photographers include Candida Höfer,
Idris Khan, Nan Goldin and Andres
Serrano. The gallery has a second
space in New York.

Vu' la Galerie
2 rue Jules Cousin
75004 Paris
www.agencevu.com

Vu' la Galerie is a contemporary
gallery focusing primarily on
photography. It presents six exhibitions
a year, illustrating the diversity of
contemporary artistic endeavour and
approaches to photography. Featured
artists include Denis Darzacq, John
Davies and Gabriele Basilico.

Galerie du jour Agnès b
44 rue Quincampoix
75004 Paris
www.galeriedujour.com

Galerie du jour Agnès b is a
contemporary art gallery founded in
1984, which specializes in photography.

Galerie Thierry Marlat
2, rue de Jarente, 75004 Paris
www.galerie-marlat.fr

Galerie Thierry Marlat is dedicated
exclusively to photography and
supports a wide range of established
contemporary artists working in the
medium. Featured photographers
include Lee Friedlander, Nan Goldin,
William Klein and Helmut Newton.
The gallery also owns a wide selection
of 19th-century and 20th-century
vintage prints.

Galerie Kamel Mennour
60, rue Mazarine
75006 Paris
www.kamelmennour.com

Galerie Kamel Mennour opened in
1999 and now has two spaces in
Paris. It exhibits works by
photographers including Martin Parr,
Alberto García-Alix and Roger Ballen
alongside a wider programme of works
in other media.

Galerie Esther Woerdehoff
36 rue Falguière
75015 Paris
www.ewgalerie.com

Galerie Esther Woerdehoff has a stock
of historic photographic imagery from
the inter-war period to the 1960s and
also represents a key group of young
photographers.

germany
Camera Work
Kantstrasse 149
10623 Berlin
www.camerawork.de

Camera Work was founded in 1997
and supports emerging talent as
well as established names. The
gallery is dedicated to photography
and represents a range of artists
who have had an impact on the
medium from the 20th century to
the present day.

Galerie Caprice Horn
Rudi-Dutschke-Strasse 26
10969 Berlin
www.capricehorn.com

Galerie Caprice Horn is a
contemporary gallery representing
a number of artists and photographers
from various countries and
backgrounds. The gallery features
photographers such as Julia Fullerton-
Batten, Daniel and Geo Fuchs, Sunil
Gupta and Edgar Martins.

Kicken Berlin
Linienstrasse 155 & 161a
10115 Berlin
www.kicken-gallery.com

Kicken Gallery features a number
of artists from the 19th and 20th
centuries, with a special focus on
the German and Czech avant-garde
of the 1920s and 1930s. Contemporary
fashion photography is shown as
well as conceptual work.

Galerie Priska Pasquer
Albertusstrasse 9–11
50667 Cologne
www.priskapasquer.de

Galerie Priska Pasquer represents a
range of modern and contemporary
artists, from Bernd and Hilla Becher
and André Kertész to Rinko
Kawauchi. The gallery works
with more than fifty artists.

Galerie Thomas Zander
Schönhauser Strasse 8
50968 Cologne
www.galeriezander.com

Galerie Thomas Zander was founded in 1996 and shows international artists from different backgrounds. The gallery presents work by artists who consider photography within the wider context of contemporary art.

Galerie Stefan Röpke
St Apern-Strasse 17-21
50667 Cologne
www.galerie-roepke.de

Founded in 1993, Galerie Stefan Röpke represents around twenty artists who create a dialogue between the traditions of painting, sculpture and photography. The gallery promotes key photographic figures such as Edward Burtynsky alongside emerging artists.

Galerie Rüdiger Schöttle
Amalienstrasse 41
80799 Munich
www.galerie-ruediger-schoettle.de

Founded in 1968 as a forum for contemporary art, the gallery has provided an opportunity for many artists to stage their first solo show in Germany. Featured artists include Jeff Wall, Rodney Graham, Thomas Struth, Andreas Gursky, Thomas Ruff and Dan Graham.

india
Vadehra Art Gallery
D-40 Defence Colony
New Delhi 110024
www.vadehraart.com

21 Ryder St
London SW1Y 6PX

Over the past twenty years Vadehra Art Gallery has exhibited works of many contemporary and modern artists. It presents exhibitions, retrospectives, publications and educational programmes to promote contemporary Indian art. There is a second space in London called Grosvenor Vadehra.

italy
Photology
Via della Moscova 25
20121 Milan
www.photology.com

Photology is one of the largest photography galleries in Italy. It presents exhibitions by contemporary and established masters: William Eggleston, Henri Cartier-Bresson, Ed Ruscha and Gregory Crewdson are some of the artists featured.

Brancolini Grimaldi
Via dei Tre Orologi 6A
00197 Rome
www.brancolinigrimaldi.com

Brancolini Grimaldi gallery aims to present emerging and young artists alongside internationally recognized names. The gallery has two locations in Italy (in Rome and Florence), both specializing in contemporary photography and video, and it opened a third venue in London in 2011.

Forma Galleria
Piazza Tito Lucrezio Caro, I
20136 Milan
www.formagalleria.com

Forma Galleria is a photographic gallery that represents over thirty international photographers. It shows works from the 20th century together with more contemporary pieces by young Italian and international artists.

japan
Foil Gallery
1-2-11 #201, Higashi-Kanda
Chiyoda-ku
Tokyo 101-0031
www.foiltokyo.com

Since it was established in 2004, Foil has published its own art books as a form of promoting artists. It represents both domestic and international talent and celebrates emerging photographers. Featured artists include Rinko Kawauchi.

Gallery Koyanagi
Koyanagi Bldg 8F, 1-7-5 Ginza Chuo-ku
Tokyo 104-0061
www.gallerykoyanagi.com

A gallery with a wide range of material, including work by photographers Olafur Eliasson, Luisa Lambri, Sophie Calle, Hiroshi Sugimoto and Hellen van Meene.

Taka Ishii Gallery
1-3-2-5F Kiyosumi, Koto-ku
Tokyo 135-0024
www.takaishiigallery.com

Taka Ishii gallery shows a selection of Japanese artists, including Nobuyoshi Araki and Naoya Hatakeyama, as well as an expanding list of international names, which includes Thomas Demand. The gallery has a second space in Kyoto.

netherlands
Galerie Paul Andriesse
Westerstraat 187
1015 MA Amsterdam
www.paulandriesse.nl

Contemporary artists such as Rineke Dijkstra, Thomas Struth and Hellen van Meene are shown alongside other established names at this gallery.

Torch Gallery
Lauriergracht 94
1016 RN Amsterdam
www.torchgallery.com

Torch gallery represents a number of Dutch and international artists. Since it opened in 1984, it has made a big impact, promoting photography as an art form and acting as a springboard for now established artists such as Anton Corbijn and Inez van Lamsweerde.

Galerie Alex Daniels/Reflex Gallery
Lijnbaansgracht 318
Amsterdam 1017 WZ
www.reflex-art.nl

Representing and showcasing modern artists since 1987, the gallery opened a second space in 2003 dedicated to young contemporary artists, focusing on photographers and painters.

Flatland Gallery
Lange Nieuwstraat 7
3512 PA Utrecht
www.flatlandgallery.com

Flatland Gallery was founded in 1983 and is situated in a former school building. It is well known for photography on an international level and has expanded into drawing, sculpture, installation, film and video.

norway
Galleri K
Bjørn Farmannsgate 6
0271 Oslo
www.gallerik.com

One of the foremost contemporary art galleries in Norway, Galleri K showcases the work of a number of international photographers including Andreas Gursky, Candida Höfer, Thomas Struth and Jakob Schmidt.

Fotogalleriet
Mollergata 34
0179 Oslo
www.fotogalleriet.no

Fotogalleriet is one of the few Norwegian galleries devoted exclusively to photographic art. It was founded in 1977 and shows a mix of Norwegian and international artists. Fotogalleriet has an in-house library and holds annual events to support the photographic community.

poland
Raster Gallery
Ul. Hoza 42 m. 8
00-516 Warsaw
www.raster.art.pl

Raster Gallery is an independent art space founded in 2001, which exhibits and represents emerging international talent as well as Polish artists such as Aneta Grzeszykowska.

south africa
Michael Stevenson Gallery
160 Sir Lowry Road
Woodstock
7925 Cape Town
www.michaelstevenson.com

Michael Stevenson Gallery was established in 1990 and deals in South African art. Recently, the gallery has added contemporary South African works to its 19th- and 20th-century paintings and now represents a number of contemporary artists including renowned photographer Pieter Hugo.

Photo ZA Gallery
153 Oxford Road, Upper Level,
Mutual Square, Rosebank
2132 Johannesburg
www.photoza.co.za

Photo ZA Gallery is one of South Africa's few galleries focusing exclusively on photographic art.

The gallery shows documentary and commercial photographic art, encompassing traditional and modern photographic techniques.

spain
Kowasa Gallery
Mallorca, 235
08008 Barcelona
www.kowasa.com

Kowasa Gallery was founded in 1997 and presents Spanish and international art to the public. The gallery stocks historic works and contemporary photographic art. It boasts a large multilingual bookstore and publishes its own catalogues.

Galería Juana de Aizpuru
C/Barquillo 44 – 1°
28004 Madrid
www.juanadeaizpuru.com

Galería Juana de Aizpuru opened in Madrid in 1983 and exhibits the work of over thirty artists working in a variety of media, including Wolfgang Tillmans, Sol LeWitt and Joseph Kosuth.

Galeria Toni Tàpies
Consell de Cent 282
08007 Barcelona
www.tonitapies.com

Galeria Toni Tàpies opened in the gallery district of Barcelona in 1994 and has since exhibited works by established international artists including João Onofre, Sol LeWitt, Jana Sterbak, Ann Veronica Janssens and Christine Borland.

sweden
Galleri Kontrast
Hornsgatan 8
SE-118 20 Stockholm
www.gallerikontrast.se

Galleri Kontrast is situated in a converted bank building. Since its opening in 1996, the gallery has focused on photography and is now a leading venue for documentary photography in Sweden, putting on twenty exhibitions a year.

CFF (Centrum Før Fotografi)
Tjärhovsgatan 44
116 28 Stockholm County
www.centrumforfotografi.com

The CFF shows six exhibitions a year, with a focus on photography. The

artists represented by the gallery take a range of approaches to the medium and include established and international as well as emerging names.

Fotografiska
Stadsgårdshamnen 22
116 45 Stockholm
www.fotografiska.eu

Fotografiska is situated in an industrial Art-Nouveau building from 1906. The gallery presents four major exhibitions per year, showcasing established contemporary photographers.

switzerland
Galerie Zur Stockeregg
Stockerstrasse 33
8022 Zurich
www.stockeregg.com

Established in 1979, Zur Stockeregg has since exhibited photographs from the early 20th century to the present. The gallery presents a number of contemporary photographers, focusing specifically on analogue photography. Stephen Gill, Richard Misrach, Joel Meyerowitz and Bae Bin-U are among the featured names.

Galerie Scalo
Weinbergstrasse 22a
8001 Zurich
www.scalo.com

This gallery specializes in contemporary art and photography. Featured artists include Bill Henson, Nan Goldin, Malick Sidibé and Gilles Peress.

united arab emirates
The Third Line
Al Quoz 3
Dubai
www.thethirdline.com

The Third Line is a gallery focusing on Middle Eastern art on a local, regional and international level. Monthly exhibitions are held alongside alternative not-for-profit events and programmes.

The Empty Quarter Fine Art Photography
Gate Village, Bldg 02
P.O. Box 506697
DIFC Dubai
www.theemptyquarter.com

Empty Quarter is the only gallery in Dubai devoted exclusively to photography and exhibits a broad range of photographic styles, including documentary, photojournalism, abstract, humanist and street photography.

united kingdom

Michael Hoppen Gallery
3 Jubilee Place
London SW3 3TD
www.michaelhoppengallery.com

Michael Hoppen Gallery was established in 1993 and specializes in photography from the 19th century to the present day. The gallery is recognized internationally and works with a number of emerging and established artists. Part of the gallery is dedicated to contemporary work by names such as Simon Norfolk, Naoya Hatakeyama, Alex Prager, Guy Bourdin and Valérie Belin.

Hamiltons Gallery
13 Carlos Place
London W1K 2EU
www.hamiltonsgallery.com

Hamiltons was established in 1977 and specializes in mid- to late 20th-century photography. The gallery presents contemporary international artists alongside its 20th-century collection. Featured artists include Miles Aldridge, David Bailey, Irving Penn, Don McCullin and Helmut Newton.

Eric Franck Fine Art
61 Willow Walk, 1st Floor
London SE1 5SF
www.ericfranck.com

Eric Franck Fine Art shows a range of international photographers from diverse backgrounds, encompassing emerging contemporary and established talent. The gallery also houses and represents the estate of Norman Parkinson.

Atlas Gallery
49 Dorset Street
London W1U 7NF
www.atlasgallery.com

Atlas Gallery was established in 1994 and specializes in classic and 20th-century vintage photography, photojournalism and fashion

photography, as well as presenting a number of contemporary photographers such as Nick Brandt, William Klein and Mark Power.

The Wapping Project Bankside
65a Hopton Street
London SE1 9LR
www.thewappingprojectbankside.com

The Wapping Project Bankside is a contemporary gallery working exclusively with film and photography. It opened in 2009 and exhibitions range from 20th-century photography to the works of contemporary international artists including Elina Brotherus, Stephen J. Morgan and Deborah Turbeville.

Timothy Taylor
15 Carlos Place
London W1K 2EX
www.timothytaylorgallery.com

Timothy Taylor Gallery was founded in 1996 and boasts an innovative programme of exhibitions, counting Diane Arbus and Adam Fuss among the featured photographers.

Flowers Galleries
32 Kingsland Road
London E2 8DP
www.flowersgalleries.com

Flowers Galleries was established in 1970 and now has two locations in London, in the East and West End, as well as a space in New York. The gallery currently represents more than twenty-five artists including Edward Burtynsky and Robert Polidori.

Frith Street Gallery
17–18 Golden Square
London W1F 9JJ
www.frithstreetgallery.com

Frith Street Gallery was founded in 1989 with the aim of presenting the best in contemporary drawing. Having since moved from its eponymous location, the gallery exhibits a range of emerging and established artists.

HackelBury Fine Art Ltd
4 Launceston Place
London W8 5RL
www.hackelbury.co.uk

HackelBury was founded in 1998 and exhibits 20th- and 21st-century fine art with an emphasis on photography.

Garry Fabian Miller, Doug and Mike Starn and Malick Sidibé are among the artists regularly shown.

Gagosian
6-24 Britannia Street
London WC1X 9JD
www.gagosian.com

Gagosian Gallery represents a strong list of well-established artists working in a range of media. The gallery has exhibited the works of photographers such as Gregory Crewdson, Ed Ruscha, Alec Soth, Sally Mann and Andreas Gursky. Gagosian has exhibition spaces in London, New York, Beverly Hills, Paris, Athens, Geneva, Hong Kong and Rome.

White Cube
25-26 Mason's Yard
St James's
London SW1Y 6BU
www.whitecube.com

The well-known White Cube gallery works with a list of high-profile international artists; among the photographers represented are Andreas Gursky, Jeff Wall, Sam Taylor-Wood, Darren Almond and Gregory Crewdson. The gallery has two contemporary spaces in London, situated in St James's and Hoxton Square.

Victoria Miro
16 Wharf Road
London N1 7RW
www.victoria-miro.com

Victoria Miro is a commercial gallery presenting the work of established and emerging artists from the United States, Europe and Asia as well as championing new talent from the UK. It opened in 1985 in its first location in Mayfair and today the gallery features photographic work by Idris Khan, Isaac Julien and William Eggleston among others.

Sprüth Magers
7A Grafton Street
London W1S 4EJ
www.spruethmagers.com

Sprüth Magers is a contemporary gallery that exhibits works by over forty artists: Thomas Demand, Richard Prince, Ed Ruscha, Philip-Lorca DiCorcia and Andreas Gursky are some of the featured photographers.

The Photographers' Gallery
16-18 Ramillies Street
London W1F 7LW
www.photonet.org.uk

The Photographers' Gallery was founded in 1971 and is the largest public gallery in London focusing only on photography. The gallery has shown historical works as well as those of established and emerging photographers, and it also features a varied educational programme, comprising awards, talks and events.

Sadie Coles HQ
69 South Audley Street
London W1K 2QZ
www.sadiecoles.com

Sadie Coles opened her eponymous gallery in 1997 and shows a wide selection of artists including Matthew Barney, Sara Lucas, Richard Prince and Hellen van Meene.

united states
Marian Goodman Gallery
24 West 57th Street
New York, NY 10019
www.mariangoodman.com

Marian Goodman Gallery was founded in 1977 and for more than thirty years has sought to introduce European artists to American and international audiences. The gallery has exhibition spaces in both New York and Paris and works to establish relationships between artists and institutions on an international level.

Hamburg Kennedy Photographs
22 East 36th Street, Penthouse
New York, NY 10016
www.hkphotographs.com

Hamburg Kennedy Photographs is a private art advisory service specializing in contemporary and photographic art of the 20th and 21st centuries. A broad inventory of vintage photography is set alongside contemporary works, with a focus on the post-war period.

Peter Fetterman Gallery
2525 Michigan Avenue, Gallery #A1
Santa Monica, CA 90404
www.peterfetterman.com

Peter Fetterman Gallery represents a group of contemporary and emerging artists and specializes in classic black-and-white photography, with an emphasis on humanist imagery. The gallery was founded in 1990.

Edwynn Houk
745 Fifth Avenue
New York, NY 10151
www.houkgallery.com

Edwynn Houk Gallery was founded in 1980 in Chicago and moved to New York in 1991. It primarily represented a group of modernist photographers, including Brassaï, Bill Brandt and André Kertész. Since then the gallery has also exhibited works by leading contemporary practitioners including Sally Mann and Robert Polidori. The gallery has a second space in Zurich.

Fraenkel Gallery
49 Geary Street
San Francisco, CA 94108
wwww.fraenkelgallery.com

Fraenkel Gallery was founded in 1979 and since then has presented almost 300 exhibitions charting the history of photography and its relationship to other artistic practices. A broad range of artists is represented, including Diane Arbus, Robert Adams, Lee Friedlander, Adam Fuss, Helen Levitt, Richard Misrach and Hiroshi Sugimoto. The gallery has also produced numerous monographs and catalogues for its exhibitions.

M + B Gallery
612 North Almont Drive
Los Angeles, CA 90069
www.mbart.com

The gallery's exhibition programme features a wide range of international photographic artists including Massimo Vitali, Jean-Baptiste Mondino, Alex Prager and Saul Leiter.

Fahey/Klein Gallery
148 North La Brea Avenue
Los Angeles, CA 90036
www.faheykleingallery.com

Fahey/Klein Gallery deals in 20th-century and contemporary photography and is dedicated to enhancing public appreciation of the medium. The gallery has a stock of more than 8,000 photographs in a variety of genres including portraiture, nudes, landscapes and still-life photography.

Robert Miller Gallery
524 West 26th Street
New York, NY 10001
www.robertmillergallery.com

Robert Miller Gallery represents over twenty artists working in a range of different media, from Bill Henson and Diane Arbus to Patti Smith and Ai Wei Wei.

Matthew Marks Gallery
522 West 22 Street
New York, NY 10011
www.matthewmarks.com

Matthew Marks Gallery was founded in 1991 and exhibits artwork in all media. The gallery puts together twelve to fourteen shows per year and represents a select group of European and American artists from various backgrounds. In 2011 a second space opened in Los Angeles.

Pace/MacGill Gallery
32 East 57th Street, 9th Floor
New York, NY 10022
www.pacemacgill.com

A long-established gallery working with more than forty international artists. Andy Warhol, Paolo Roversi, Alfred Stieglitz, Robert Rauschenberg, Walker Evans, Richard Misrach and Chuck Close are some of the names represented.

Yancey Richardson Gallery
535 West 22nd Street
New York, NY 10011
www.yanceyrichardson.com

Yancey Richardson Gallery is a leading art dealer in New York focusing on work by established and emerging contemporary photographers.

Staley–Wise Gallery
560 Broadway, Suite 305
New York, NY 10012
www.staleywise.com

Staley–Wise Gallery opened in 1981 and focuses on works by the masters of fashion photography. Featured artists include David LaChapelle, Lillian Bassman, Steven Klein and Patrick Demarchelier.

Laurence Miller Gallery
20 West 57th Street
New York, NY 10019
www.laurencemillergallery.com

Laurence Miller Gallery opened in 1984 and specializes in American photography since 1940, Asian photography since 1950 and contemporary photo-based art.

Robert Klein Gallery
38 Newbury Street, 4th Floor
Boston, MA 02166
www.robertkleingallery.com

Robert Klein Gallery is dedicated exclusively to fine-art photography. Founded in 1980, it focuses on established photographers from the 19th and 20th centuries, including Ansel Adams, Berenice Abbott, Irving Penn, Henri Cartier-Bresson and Walker Evans as well as contemporary artists such as Julie Blackmon and Jeff Brouws.

Robert Koch Gallery
49 Geary Street, 5th Floor
San Francisco, CA 94108
www.kochgallery.com

Robert Koch Gallery exhibits photography from the 19th century through to the present day. The gallery was established in 1979 and concentrates on the development and analysis of the history of photography as well as on the support of emerging artists.

Rose Gallery
Bergamot Station Arts Center
2525 Michigan Avenue
Santa Monica, CA 90404
www.rosegallery.net

Rose Gallery was founded in 1991 and represents a diverse range of modern and contemporary artists. Dorothea Lange, William Eggleston, Diane Arbus and Martin Parr are some of the photographers the gallery has worked with.

Bonni Benrubi Gallery, Inc.
41 East 57th Street, 13th Floor
New York, NY 10022
www.bonnibenrubi.com

Bonni Benrubi was founded in 1987 and specializes in photography. The focus is on 20th-century and contemporary photography, and both beginners and veteran collectors are accommodated.

L. Parker Stephenson
764 Madison Avenue
New York, NY 10065
www.lparkerstephenson.com

L. Parker Stevenson is a private photographic dealer specializing in classic and avant-garde photography of the 20th century and representing a select number of contemporary artists.

Robert Mann Gallery
210 Eleventh Avenue, Floor 10
New York, NY 10001
www.robertmann.com

Robert Mann Gallery is a photographic gallery that features forty-five artists from a range of generations and backgrounds. It exhibits works by acclaimed photographers such as Weegee, Alfred Stieglitz, Paul Strand, Diane Arbus, Brassaï, Ansel Adams and Robert Frank.

Luhring Augustine
531 West 24th Street,
New York, NY 10011
www.luhringaugustine.com

Luhring Augustine was founded in 1985 and represents a number of contemporary and international artists who work in painting, drawing, sculpture, video and photography.

photography fairs

the aipad photography show
Park Avenue Armory, New York
The Association of International
Photography Art Dealers (AIPAD)
2025 M Street NW, Suite 800
Washington, D.C. 20036
www.aipad.com

One of the foremost events in the
international photography calendar,
this annual fair is organized in spring,
attracting over seventy galleries/dealers.

**arco madrid: feria internacional
de arte contemporáneo**
Feria de Madrid, 28042 Madrid
www.ifema.es/ferias/arco/default.html

ARCO is a contemporary art fair held
annually in Madrid that brings together
artists, collectors, curators, art
enthusiasts and novice collectors.

the armory show
Pier 94, West Side, New York
www.thearmoryshow.com

The Armory Show is America's leading
fine-art fair for 20th- and 21st-century
art. Since its founding in 2000 it has
become a highlight of the New York
art scene calendar.

**art basel & art basel miami
beach**
Messe Basel, Messeplatz,
4005 Basel, Switzerland/
Miami Beach Convention Center
Miami Beach, Flo.
www.artbasel.com

Art Basel is the premier international
art show for contemporary works,
with over 250 galleries taking part.
The sister event in Miami features a
programme of crossover events held
throughout the city's Art Deco district.

art cologne
Kölnmesse, Messeplatz 1
50679 Cologne
www.artcologne.com

Art Cologne has a long tradition, with
international galleries showcasing the

best of classic modernist, post-war and
contemporary art.

**fiac (foire internationale d'art
contemporain)**
Avenue Winston Churchill, 75008 Paris;
Jardin des Tuileries; Jardin des Plantes
www.fiac.com

FIAC art fair has been running in
Paris since 1974 and since 2005 has
expanded to cover exhibition sites
at the Grand Palais, the Jardin des
Tuileries and the Jardin des Plantes.

frieze
Regent's Park, London
www.friezeartfair.com

Taking place each year in London's
Regent's Park, the famous Frieze fair
showcases contemporary artists
represented by an array of international
galleries. Established in 2003, the fair
includes specially commissioned
projects and talks.

**fotografia festival: festival
internazionale di roma**
Various locations, Rome
www.fotografiafestival.it

This fair takes place over two
months each spring with a variety
of exhibitions held around the city.
Its Rome commission selects
international photographers to
portray the city in new ways.

grid
Various locations, Amsterdam,
and Almere, Amstelveen,
Haarlem and Zaanstad
www.gridphotofestival.com

A biennial event initiated by the
Stichting Amsterdam Photo
(Photography Foundation) in 2004
to showcase the latest trends. It was
extended in 2010 to include Almere,
Amstelveen, Haarlem and Zaanstad,
and spin-offs of the festival are being
established in Bergen and Purmerend.

the london photograph fair
Holiday Inn, Bloomsbury,
Coram Street, London WC1N 1HT
www.photofair.co.uk

Approximately forty dealers exhibit
photographic works with an emphasis
on late 19th-century and early 20th-
century prints. Contemporary material
is now increasingly represented at this
fair, which is held four times a year.

paris photo
Grand Palais, Paris
www.parisphoto.fr

Previously held at the Carrousel du
Louvre, Paris Photo Fair now takes
place at the Grand Palais. Over 100
international galleries come together
every year to make this Europe's
most significant photography fair.

photo españa
C/ Verónica 13 , 28014 Madrid
www.phedigital.com

The International Festival of
Photography and Visual Arts Madrid
features more than seventy exhibitions
showcasing works by over 350 artists.
It started in 1998 and has become
one of the largest cultural events
in Spain.

photo la
7358 Beverly Boulevard
Los Angeles, CA 90036
www.photola.com

Photo l.a. attracts upwards of 10,000
visitors each January with an array of
exhibitors showcasing photography
and multimedia installations.

les rencontres d'arles
Various locations, Arles, France
www.rencontres-arles.com

This photography festival has taken
place every year since 1968 around the
heritage buildings of Arles. A varied
programme of events runs throughout
the three months of exhibitions.

picture credits & acknowledgments

Miles Aldridge © Miles Aldridge
Benoit Aquin © Benoit Aquin
Olivo Barbieri © Olivo Barbieri, courtesy Yancey
 Richardson Gallery, New York
Peter Beard © Peter Beard/Art + Commerce
Jonas Bendiksen © Jonas Bendiksen/ Magnum
 Photos
Elina Brotherus © the artist, The Wapping Project
 Bankside, London, and gb agency, Paris
Edward Burtynsky © Edward Burtynsky, courtesy
 Flowers, London, Nicholas Metivier, Toronto
Kelli Connell © Kelli Connell
Gregory Crewdson ©
Denis Darzacq © Denis Darzacq, courtesy VU
 Gallery Paris
Tacita Dean © Tacita Dean, courtesy the artist,
 Frith Street Gallery, London, and Marian
 Goodman Gallery, New York and Paris
Philip-Lorca diCorcia © Philip-Lorca diCorcia,
 courtesy of David Zwirner Gallery and Sprüth
 Magers, Berlin, London
Ahmet Ertug © Ahmet Ertug
Julia Fullerton-Batten © Julia Fullerton-Batten
Stephen Gill © Stephen Gill
Aneta Grzesykowska © Aneta Grzeszykowska,
 courtesy Raster Gallery
Sunil Gupta © Sunil Gupta
Naoya Hatakeyama © Naoya Hatakeyama,
 courtesy Taka Ishii Gallery
Bill Henson © courtesy the artist and Roslyn Oxley
 9 Gallery, Sydney
Zhang Huan © Zhang Huan
Tom Hunter © Tom Hunter
Nadav Kander © Nadav Kander, courtesy Flowers
 Galleries
Izima Kaoru © Izima Kaoru
Rinko Kawauchi © Rinko Kawauchi
Idris Khan © the artist, Victoria Miro Gallery,
 London, Yvon Lambert Gallery, Paris, and
 Fraenkel Gallery, San Francisco
Edgar Martins © images courtesy the artist
Richard Misrach © Richard Misrach, courtesy
 Fraenkel Gallery, San Francisco, Marc Selwyn
 Fine Art, Los Angeles, and Pace/MacGill
 Gallery, New York
Stephen J. Morgan © Stephen J. Morgan
Youssef Nabil © Youssef Nabil
Simon Norfolk © Simon Norfolk
Martin Parr © Martin Parr/Magnum Photos
Alex Prager © Alex Prager, courtesy Yancey
 Richardson Gallery, New York
Wang Quingsong © Wang Quingsong
Ed Ruscha © Ed Ruscha, courtesy Gagosian Gallery
Alec Soth © Alec Soth/Magnum Photos
Thomas Struth © Thomas Struth
Mitra Tabrizian © Mitra Tabrizian
Nazif Topçuoğlu © Nazif Topçuoğlu
Ruud van Empel © Ruud van Empel, courtesy
 Flatland Gallery Utrecht-Paris
Hellen van Meene © Hellen van Meene, courtesy
 Sadie Coles HQ, London

acknowledgments
Sincere thanks to my family and friends for their support and forbearance over many long months. To Malcolm Cossons, for proposing the idea in the first place, and for his eternal optimism. To Tom Shipman, for his assistance in gathering material for the reference sections. To all the photographers, their assistants and gallery representatives, who have given generously of their time to talk about their work, supply images and answer countless questions.

Editor's acknowledgments:
Thanks to Jenny, Harland and Ariadne for all the time it took.

index